MW00618546

IMAGES
of America

AROUND
NEDERLAND

ON THE COVER: Several stage companies offered Tallyho excursions in Boulder Canyon in the early 1900s. The sightseeing and picnic trips were popular features in the summer and included stops at all the scenic spots in the canyon, including Castle Rock, Boulder Falls, and the Perfect Tree, where this photograph may have been taken. (Eldora Community/Bolton Collection.)

IMAGES
of America

AROUND
NEDERLAND

Kay Turnbaugh

ARCADIA
PUBLISHING

Copyright © 2011 by Kay Turnbaugh
ISBN 978-0-7385-8149-1

Published by Arcadia Publishing
Charleston, South Carolina

Printed in the United States of America

Library of Congress Control Number: 2010926990

For all general information, please contact Arcadia Publishing:
Telephone 843-853-2070
Fax 843-853-0044
E-mail sales@arcadiapublishing.com
For customer service and orders:
Toll-Free 1-888-313-2665

Visit us on the Internet at www.arcadiapublishing.com

For Bill

CONTENTS

ACKNOWLEDGMENTS

This book owes its existence to the generosity of a number of people, some of whom I've never met.

The Nederland Area Historical Society shared its archive of photographs and kindly read the draft manuscript. When I contacted George and Sandra Breymaier of Berlin Center, Ohio, about their grandfather's scrapbook, they most generously allowed me to scan their photographs. Mary Wingate and the Sterling family also agreed willingly to share their photographs, as did Sue Leto of Nederland, who is the guardian of the Jimmy Griffith collection.

Eldora has saved much of its history through stories published in the town newsletter, currently edited by Diane Brown. Earl and Barbara Bolton answered questions and told me many stories about Eldora and their relatives, the Boltons and the Lillys. They have collected many, many photographs over the years, and they most graciously share them here, but they wanted to make sure I thanked the entire Eldora community for cherishing and saving its past.

My greatest thanks go out to everyone who has held onto the stories and photographs from our past—I am deeply indebted to you.

INTRODUCTION

Before the hay fields were buried by a reservoir, ancient people passed through the lush green valley dotted with the nodding white faces of mariposa lilies. They were migrating across what we know today as the Continental Divide, and they passed what became Nederland on their way to and from the passes that cut through the rugged mountains rising just to the west.

By 1810, hunters and trappers passing through the same meadow found beaver in the creek that wandered down the middle of the valley and elk and deer in the nearby hills.

One of those hunters decided to stay in the high-mountain meadow. It looked like good ranch land to him, and he was ready to settle down. Nathan W. Brown, or Bolly as his friends called him, bought 160 acres with scrip money from the Civil War and built a log cabin for his home on the rich meadow land. Before long, his two-story log home became Brown's Mountain House and later Middle Boulder House, a welcoming inn for hunters and prospectors in the area. As more houses were built near his, the settlement was first called Brown's Crossing or Brownsville, then Middle Boulder, after the creek that swooped and gurgled through the meadow.

A tall, sinewy man with a slight stoop and a bald head, it was rumored (with probably a good bit of hyperbole) that even at age 50, Nathan Brown could walk the 20 miles from Boulder to Nederland in an hour and a half.

One of the hunters who stopped at Brown's inn in the summer of 1864 was Sam Conger. Conger was born in Monroe County, Ohio, on July 1, 1833. At age 17 he left home and crossed the plains in a wagon. He worked first around Central City, exploring, hunting, and prospecting. In later years, his friends claimed that Conger was a government scout during the Indian wars and was a close friend of Buffalo Bill Cody. Conger made his name in the Nederland area as a prospector. On his hunting trip, Conger found an unidentifiable ore a few miles west of Brown's inn that he took with him to Central City. He left it in the barn on a friend's ranch and did not get it assayed until 1869.

When he learned the value of the ore, he returned to the area and staked several claims with a couple of friends in an area they named Cariboo (later changed to Caribou). As the news spread about the new discovery of silver, Caribou boomed, and roads were built to bring supplies, equipment, and miners to the camp. Nederland became the site of several mills and a stage stop and supply town. Not much remains of Caribou, the booming silver camp that was home to 3,000 hardy souls in spite of its extreme altitude of 10,000 feet and harsh winter weather. Today's visitors will find the remnants of two stone buildings, some of the rock walls built by the Cornish miners, and a few of the many roads that crisscrossed the area. One of the mines is still being worked by a modern-day miner named Tom Hendricks.

Nederland also benefited from Eldora's brief gold boom, again serving as a transportation and trade center. And then Nederland experienced its own boom during World War I when tungsten was discovered in the local area. Tungsten's ability to harden steel was in demand during the war as the production of weapons dramatically increased.

Nederland became a center for the area's telegraph system, and it continued to benefit from being located at a crossroad. At first it was just one stop on the wagon road between Ward and Central City, but after a toll road was built in Boulder Canyon linking Boulder and Caribou, Nederland benefited from both north-south and east-west traffic.

In addition to mining, the area's meadows are still home to a number of ranches, many of them with a rich history. The old Tucker Ranch eventually was combined with several others to form what today is Caribou Ranch. The ranch has been a boys' camp, home to the famous Van Vleet Arabian horse ranch, the set for the remake of the movie *Stagecoach*, and the Caribou recording studio.

After mining died out, the area's spectacular scenery attracted tourists and recreationists. When the Colorado and Northwestern Railroad built tracks into the mountains from Boulder to haul ore from the area's mines and mills, the line discovered a lucrative side business by calling itself the Switzerland Trail and attracting passenger traffic by hosting wildflower excursions. Local business people cashed in on the new business, leading hikers and horseback riders to Arapaho Glacier and to fishing and boating on high mountain lakes and streams. After Barker Dam was built and Hannah Barker's hay ranch was flooded to make a lake, Nederland found it too had another attraction for visitors. Small cabins were built in "auto camps" to attract people traveling the newly improved roads by automobile. For years, Nederland's rodeo, and later the Jamboree rodeo, attracted summertime visitors.

Today Nederland and the former mining towns that surround it are still home to independent, hardy people. Tourists and recreationists still throng to the area to ski, snowboard, and snowshoe in the winter at Eldora Mountain Resort and in the backcountry, and to hike, bike, and fish in the summer. Congress established the Indian Peaks Wilderness Area and the James Peak Wilderness Area to protect the scenery that has been sought after for the last 100 years. Many of the popular hiking and ski trails were built on old logging and mining roads—and on the old railroad bed. Visitors come for the town's Mining Days celebration in late July, music and arts festivals, the Carousel of Happiness, and the quirky Frozen Dead Guy Days.

In these pages are just some of the photographs of life in the early years of the Nederland area. Many of the communities in these photographs have completely disappeared; others remain only in a few foundations or weather-beaten buildings. Others, like Eldora, have maintained their past so well that walking through them is like making time stand still. Nederland does not have many old buildings left, but those that still stand all have stories to tell. The old Wolftongue Mill remains, towering over the creek as it has since it was first built to process Caribou's ores. Town hall was once one of Nederland's theaters, and the First Street businesses occupy some of the buildings that were constructed to serve the miners who flocked to town during the tungsten boom.

History books and recollections of old-timers often conflict. Although there are bound to be some mistakes in the information gathered and used in these pages, it is hoped that they are minor and do not distract from the story that the area has to tell because it is a fascinating one.

One

NEDERLAND

Native Americans hunted in the meadows and mountains surrounding Nederland, and hunting is what brought the first white men to the area. Nathan Brown stayed and built a house near Middle Boulder Creek about 1864, which later was used as an inn, and the tiny collection of buildings on the wagon road between Ward and Black Hawk was called Brownsville. Another hunter and prospector, Sam Conger, discovered silver and staked a claim in 1869 in an area that became the mining camp of Caribou.

Nederland turned from a ranching community to a transportation and supply center. When a Dutch company, the Mining Company Nederland of The Hague, bought the Caribou Mine, the community that had been called Brownsville, Dayton, and Middle Boulder took on the name of Nederland. As many as 100 passengers a day rode the stages on the Boulder-Caribou toll road, and beds in the stage stop town of Nederland were rented in eight-hour shifts. Extra doors were added to saloons, and restaurant patrons were expected to be finished eating in 20 minutes. The scene was repeated during the late 1890s, when gold was discovered at Eldora.

Like most mining towns, Nederland declined when the bottom dropped out of the silver and gold markets. It suffered several fires, and the flu epidemic of 1916–1917 took a heavy toll. But its fortunes changed again with the discovery of tungsten by Sam Conger, the same man who discovered silver in Caribou. During World War I, in its third and biggest boom, Nederland's population swelled to 3,000—twice the size it is today—and another 2,000 were estimated to live nearby. The Conger mine became the greatest tungsten mine in the world. Between 1913 and 1916, about $15 million worth of tungsten was mined from the area each year. When the war ended, mining and milling shut down, stores closed, and many houses were left vacant as the miners moved out. During World War II, Nederland felt another flurry of mining activity as tungsten once again was in demand.

Today Nederland is again thriving as a recreation and commercial center for the area.

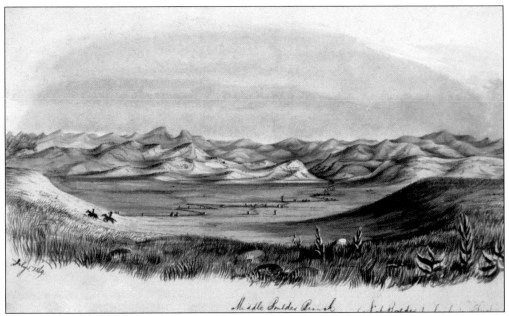

Hunters and prospectors wandered the mountains west of Boulder in 1869, when this drawing was made. In 1864, hunter Sam Conger found some promising surface ore, and he stashed it in a friend's barn. Five years later, he finally got it assayed, and he sent friends Billy Martin and George Lytle to stake claims for the three of them. Those claims were just the beginning of the rich mining history of Caribou and Nederland. (U.S. Geological Survey.)

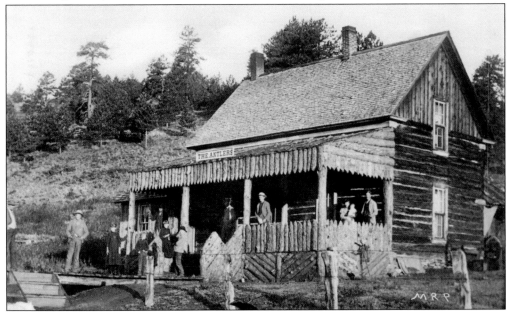

The area's meadows also attracted ranchers, and by 1870 the community was known as Brownsville, named for Nathan W. Brown, an early settler and innkeeper. This house was built for Abel Goss by R. Parsons in 1867. It was later used by Mary Roose as a hotel before she built a larger hotel in Nederland. Then the Hetzers lived in it and ran a hay ranch in the meadow that later was flooded for Barker Reservoir. (Goldie Cameron/Sterling family.)

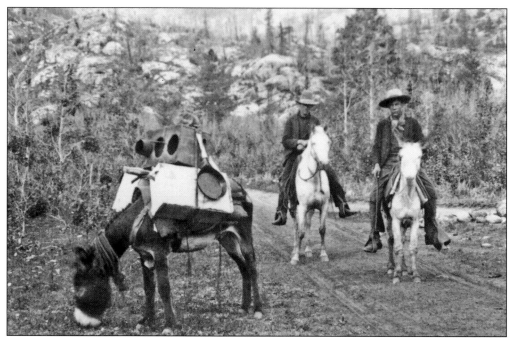

A mule was a prospector's best friend. The sure-footed creatures could carry heavy loads and work hard all day. When the miners no longer needed them and did not want to feed them, they just let them loose to fend for themselves. Town children had use of them during the winter months, but had to give up their newfound pets when the miners returned in the spring. (Nederland Area Historical Society Collection.)

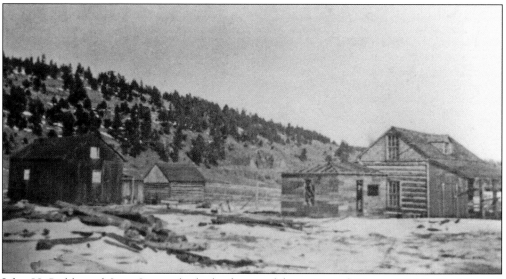

John H. Pickle and Sam Conger built the first road from Central City to Middle Boulder and Caribou in 1870. Pickle moved to Nederland from Central City, built this house, and opened a grocery store on Main Street. He also served as the president of the Central City, Nederland, and Caribou Telegraph Company. By 1874, Nederland was known as a telegraphic center with lines radiating to Caribou, Central City, Georgetown, Boulder, and Longmont. (Nederland Area Historical Society Collection.)

In 1872, Anthony Arnett, Amos Widner, and William Pound decided to build a road in Boulder Canyon to connect Boulder to Caribou. They surveyed the route on the winter ice because the canyon walls were too steep to find a route in the summer. Building the road took an immense amount of blasting and hard labor. When finished, it had over 30 bridges and in many places was built on poles and boulders with logs for the road bed. The money received from the tolls charged to use the road never did pay back the men who built it because of the constant maintenance it needed. These photographs show a bridge at Castle Rock and the new road as it continued uphill from Castle Rock. (U.S. Geological Survey/photograph by W. H. Jackson.)

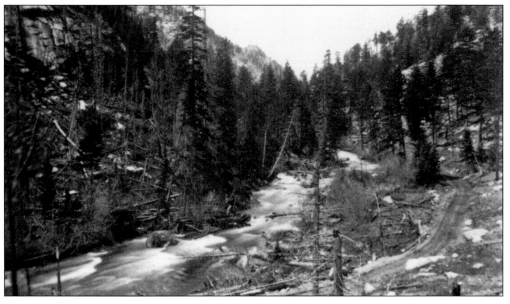

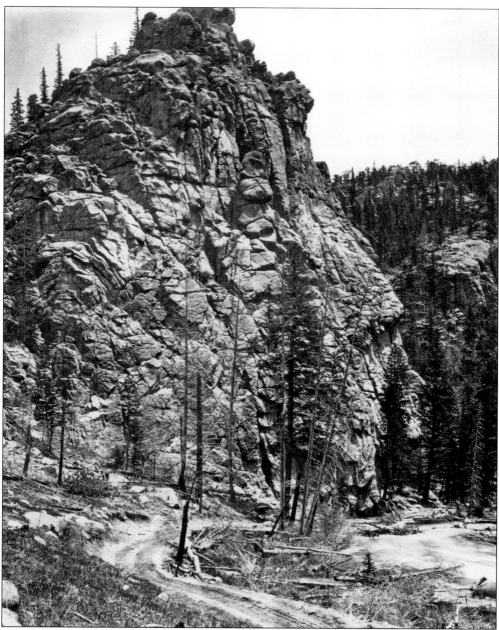

The new road up Boulder Canyon that connected Boulder to Caribou was finished in 1873, and it greatly improved transportation to the mining camps. Here it weaves around Castle Rock. Although the new road was popular with tourists, teamsters were not as happy with it. It was narrow and did not have many turnouts, which meant that when two vehicles met, one would unhitch and upset on the road so the heavier rig could pass. Drivers of freight teams attached bells to the horses' harnesses, and at night they hung a lantern from the front end of the wagon box. Castle Rock has remained a popular spot to stop for a picnic. Today climbers regularly test their skills on Castle Rock. Today's road goes to the left of the massive rock, and a fragment of the older road remains along the alignment shown in this photograph. (U.S. Geological Survey/ photograph by W. H. Jackson.)

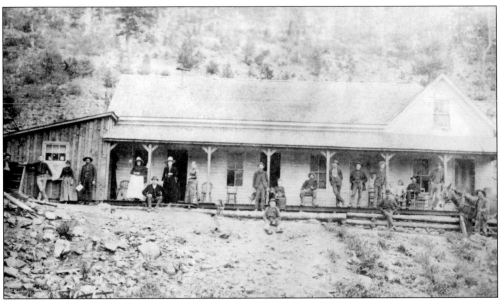

It took a day for coaches and loaded wagons to make the pull from Boulder to Caribou. In 1873, Hank Pryor, who ran the American House relay station, was famous for the tasty ham and egg snack he offered hungry passengers while they waited for a fresh team of horses to be hitched to their stage at the half-way point in Boulder Canyon. (Goldie Cameron/Sterling family.)

Wesley Hetzer moved his family to Middle Boulder in 1872. Two years later, he built the Hetzer House Hotel. The *Boulder County News* described it in 1877 as having a dining room, parlor, and office on the first floor, with "nice airy sleeping apartments" on the second. "The Hetzer is commended to the traveling public. It is the stage house and second to none in the hill country." (Nederland Area Historical Society Collection.)

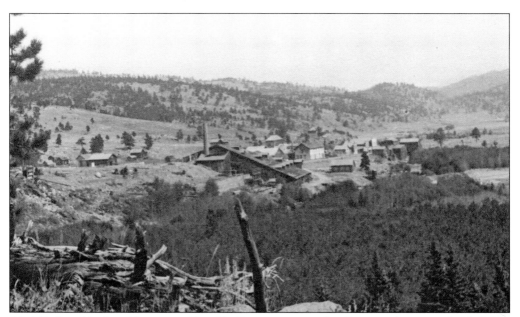

Abel D. Breed built a 10-stamp mill at Caribou to process the silver ore, but soon decided that Brownsville (later Nederland) was a better site. The second Caribou Mill opened in Brownsville in 1871. The chlorination mill could handle 15 tons of ore every 24 hours. In 1873, it employed 18 men who earned $3 a day, and it consumed 250 cords of wood a month at a cost of $2.50 per cord. (Nederland Area Historical Society Collection.)

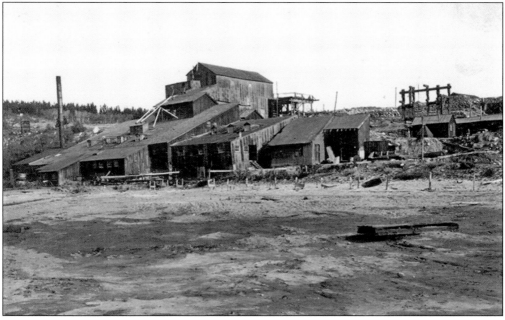

The Wolf Tongue Mill was running at full capacity in 1911. This photograph shows the mill and tailings and the framework at right where the stamps for milling the Caribou silver ores stood. Most of the area's mills concentrated low-grade ore for further processing in a smelter, but the Wolf Tongue turned out silver bars. The mill burned down in 1927 and was rebuilt the next year. It still stands today. (U.S. Geological Survey/photograph by F. L. Hess.)

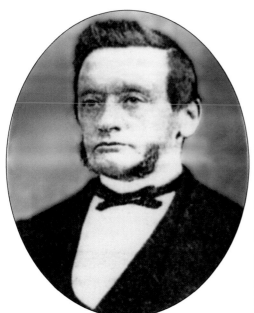 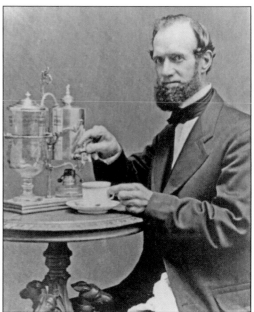

Abel Breed (right), a 59-year-old entrepreneur from Cincinnati, paid $50,000 for one-half of the Caribou Mine in 1870. Breed was a wealthy manufacturer of patent medicines and a partner in one of the country's largest undertaking firms. Breed and his partner Benjamin Cutter, an experienced miner, poured money into the Caribou Mine, and it yielded about $70,000 in their first season. Here Breed serves himself tea from a coffee/tea set made from the Caribou Mine's silver. In 1873, Breed sold the Caribou Mine to "Gentlemen of The Hague, Holland," for $3 million. One of the organizers of the Mining Company Nederland was Dr. Pieter Philip van Bosse (left), former minister of finance and colonies. Before the Dutch could take control, Breed mined all the available ore. The Dutch company had no money left to build the mine back up, and it quickly folded, but not before giving its name to Nederland. (Nederland Area Historical Society Collection.)

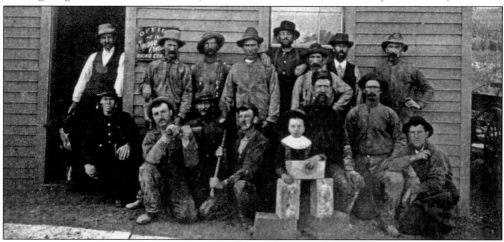

The Caribou Mine's great wealth was promoted in national fairs and exhibits. In 1873, bars of Caribou silver were laid in front of the Teller House entrance for Pres. Ulysses S. Grant's visit to Central City. The publicity stunt brought fame to the Caribou Mine and mill in Nederland, where the silver bars were cast. Here the mill workers posed with Maude Bryant, daughter of William Bryant, who operated the mill for 13 years. (Nederland Area Historical Society Collection.)

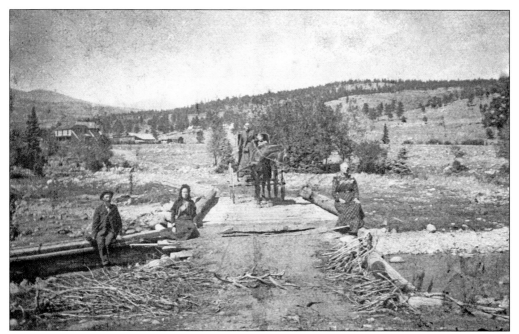

George Cecil and Jemma Cecil pose with Ella (Cecil) Beach (right) on one of Nederland's log bridges sometime in the late 1890s. Ella Cecil came to Nederland as a mail-order bride for Oren Beach. The two-story structure in the background is buttressed by poles for Nederland's infamous winter winds. (George and Sandra Breymaier, Berlin Center, Ohio.)

A wagon loaded with poles and lumber makes its way up Boulder Canyon Road, which needed constant repair after it was built. The poles may have been used to lay across the road in places that were perpetually wet, to make what was called corduroy, which would keep heavily loaded wagons from getting stuck in the mud. Or the materials may have been for bridge building. (Nederland Area Historical Society Collection.)

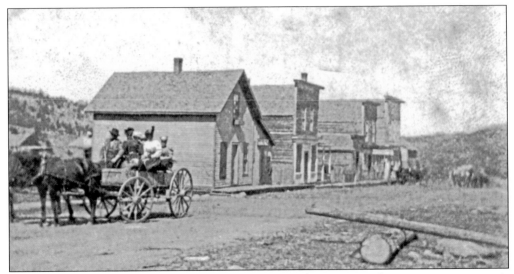

Nederland's main street in the late 1890s had a grocery and variety store, liquor store, wagon-repair shop, smithy and paint shop, and a hotel, all fronted by their own wooden boardwalks. Some of the buildings even had stylish false fronts. About this time, Nederland was prospering again with the gold boom in Eldora. (George and Sandra Breymaier, Berlin Center, Ohio.)

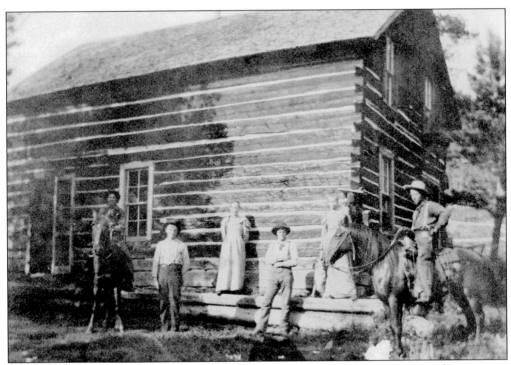

Oren Beach grew up in Nederland and stayed on to become one of the town's upstanding citizens. After his mother died, he sold her property to the Central Colorado Power Company, which was planning to build a reservoir and a hydroelectric facility. For his own family, he built this log house on land that eventually became the Beach block in Nederland. Frank Lytle is the man on horseback on the right. (George and Sandra Breymaier, Berlin Center, Ohio.)

John O. (Oren) Beach and his mail-order bride Ella pose with their son, Willie. Oren came to Colorado with his mother and three brothers, Henry, Mate, and Till, after the Civil War. Mary Beach homesteaded west of the small town of Dayton (Nederland). She was the widow of a Civil War veteran, and she may have received a small pension, but the family had very little, and old-timers remember the boys slept on a tick filled with cornhusks. (George and Sandra Breymaier, Berlin Center, Ohio.)

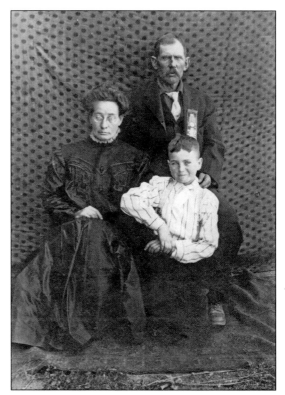

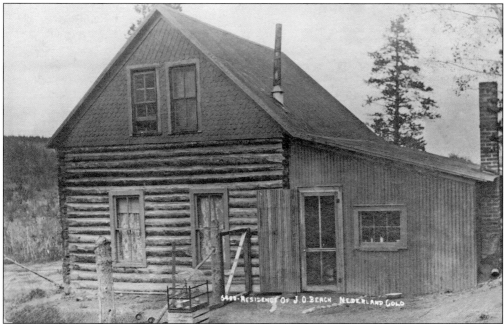

The Oren Beach house had a fenced yard and curtains. An addition to the original log home was sided with metal and included a brick chimney. The second floor siding was a fancy touch, and note the different kinds of windows. The cage in the foreground may have been for a pet bird. (George and Sandra Breymaier, Berlin Center, Ohio.)

George Breymaier's mother died when he and his sister Louise were small children. Since it was unheard of for a father to raise children on his own, George (above) and Louise were put into a Catholic orphanage. The Baxter family adopted George, and they moved to Nederland when George was about five years old, and that is where he grew up. About 1897, Clarissa Lucetta (below, right) came to Nederland to visit her relatives, the Beaches, at their home pictured here. She and George (third from right) fell in love. About the same time, George's sister Louise managed to trace George to Nederland and told him that he was actually a Breymaier. George and Lucetta married and returned to Ohio. George took his given name of Breymaier and never returned to Nederland. George and Lucetta celebrated their 50th anniversary in 1947. (George and Sandra Breymaier, Berlin Center, Ohio.)

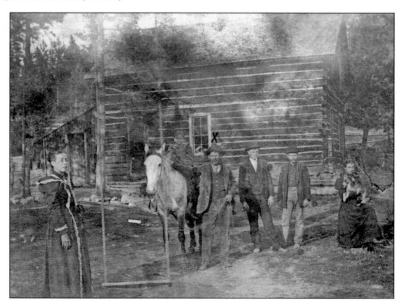

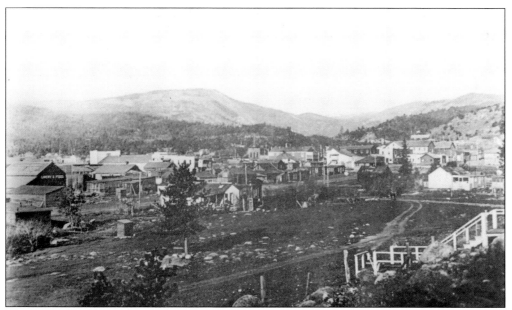

This view of Nederland from the steps of the Antlers Hotel in 1909 shows an orderly, booming town with a livery and feed store on the left and the Hetzer Hotel, the two-story white building, almost at the west end of the busy street. Very few of these buildings remain today. (Nederland Area Historical Society Collection.)

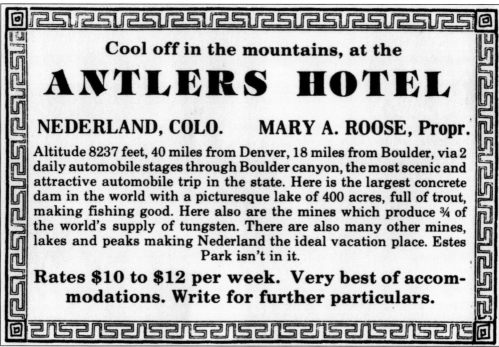

Cool off in the mountains, at the

ANTLERS HOTEL

NEDERLAND, COLO. **MARY A. ROOSE, Propr.**

Altitude 8237 feet, 40 miles from Denver, 18 miles from Boulder, via 2 daily automobile stages through Boulder canyon, the most scenic and attractive automobile trip in the state. Here is the largest concrete dam in the world with a picturesque lake of 400 acres, full of trout, making fishing good. Here also are the mines which produce ¾ of the world's supply of tungsten. There are also many other mines, lakes and peaks making Nederland the ideal vacation place. Estes Park isn't in it.

Rates $10 to $12 per week. Very best of accommodations. Write for further particulars.

An advertisement for the Antlers Hotel in 1916 touted the area's mines, the world's largest concrete dam, the good fishing, and the fact that Estes Park "isn't in it." Apple trees and chokeberry bushes still grow on the property, on a small hill just west of Barker Reservoir, which is now home to Nederland's Catholic church. (Nederland Area Historical Society Collection.)

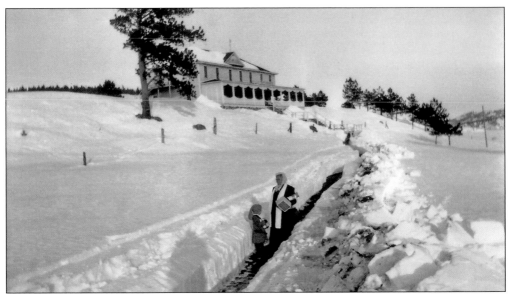

The Antlers Hotel, shown here on December 5, 1913, was built in 1897 by Mary R. Roose. She did very well with it by operating only in the summer, when pleasure and health seekers were quite numerous. The hotel served as a hospital during the great flu epidemic of 1918 that took many Nederland lives. The Catholic church now occupies the site. (Goldie Cameron/Sterling family.)

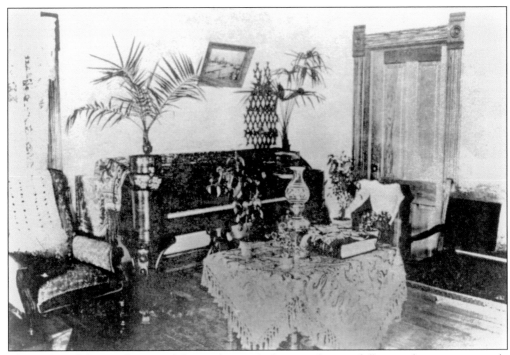

The parlor of the Antlers Hotel featured potted plants and a wood floor and was sumptuously furnished with comfortable chairs and a piano for the guests' pleasure. The hotel was open only in summers, catering to the tourist trade, until the tungsten boom, when Mary Roose began operating year-round. (Nederland Area Historical Society Collection.)

Mary Jane Beachly came to Rollinsville with her husband during the Colorado gold rush. William Beachly died in 1862 when their son, John Albert, was only four months old. Soon after, Mary Jane married William Bryant, and the family settled in Nederland where William operated Breed's mill. Mary Jane was a skilled horsewoman and often competed, once winning a writing desk inlaid with mother of pearl. William died in 1889. Mary Jane was 96 when she died. (Nederland Area Historical Society Collection.)

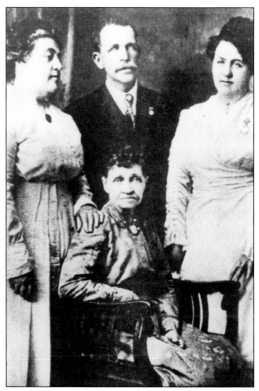

A young Jim Moore was in the freight business in Nederland in 1897, along with Richard Crow and W. L. Newby. The Newby family owned a grocery and liquor store on Nederland's main street in the early days. Moore was the son of Dr. Alice Moore, who may have been Nederland's first doctor, and the grandson of Alfred Tucker, one of the original homesteaders of what eventually became Caribou Ranch. (George and Sandra Breymaier, Berlin Center, Ohio.)

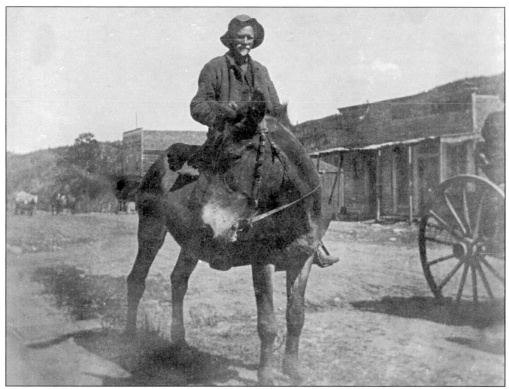

Charles Loveless was "an old bachelor" who was 74 years old when this photograph was taken of him on his mule Jumbo on Nederland's main street. He lived near the Beach and Baxter families, and he was a fixture around town in the late 1890s. (George and Sandra Breymaier, Berlin Center, Ohio.)

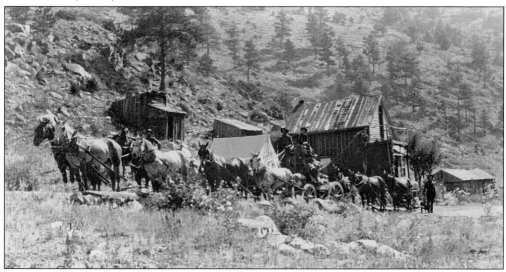

This freighting outfit used eight horses to pull the heavy wagon and four mules hitched to a pusher in the rear of the wagon. This was the kind of outfit used to haul mining machinery over the steep mountain roads to a new mine installation during the silver and gold mining booms. (Eldora Community/Bolton Collection.)

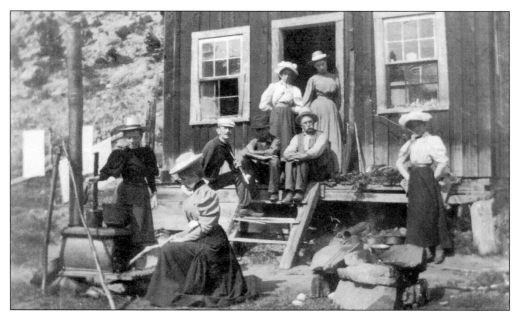

An outing at the Tucker Ranch included fishing and cooking out for the Read and Wilson families in the late 1890s. Even the women folk took time to relax and have their picture taken. Alfred Tucker homesteaded on land west of Nederland in 1870. He was not a mining man, but he knew land that would make a good ranch. Daughters Alice and Rose Tucker were students at the Nederland school in 1875, and Alice went on to become a doctor. Another daughter, Martha Jane, married Dan Lytle, and although they lived in Nederland for only four years, their son made Nederland his home. Tom Tucker, the only son, married Mary Church and bought a mountain ranch that had been homesteaded by Henry Commeaw. After Tom's death, Dr. Moore bought his ranch and turned it into a boys' camp in the 1920s. The ranch eventually became the Van Vleet Ranch, famous for Arabian horses, and then the Caribou Ranch, famous as a recording studio. (George and Sandra Breymaier, Berlin Center, Ohio.)

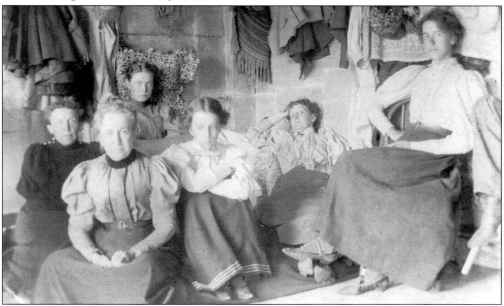

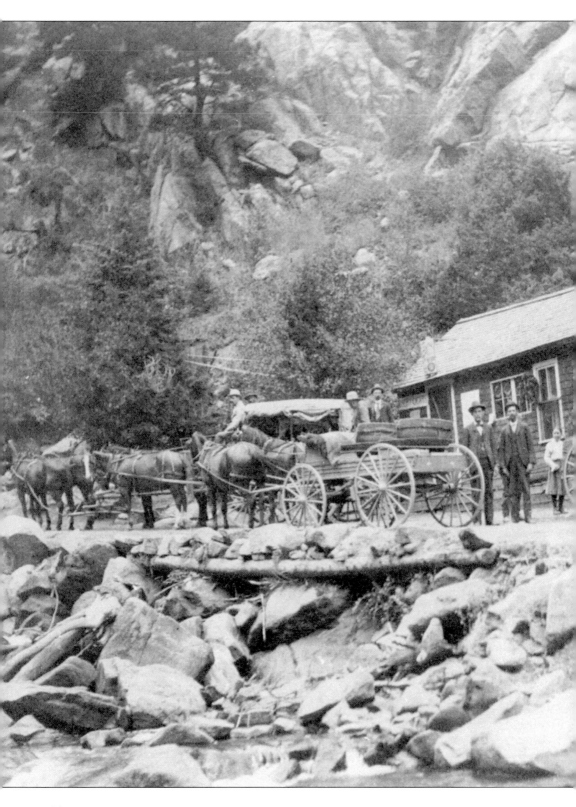

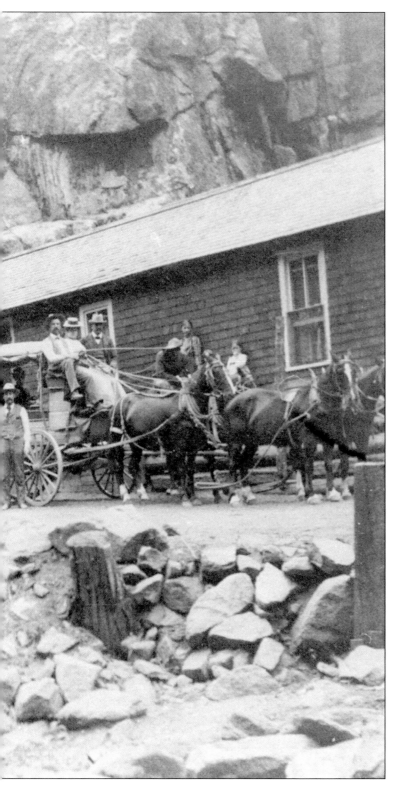

Two Talmage and Lilly stages are shown here at a "meet" at the blue Half-Way House in Boulder Canyon around 1898. Harve Robinson is driving the up-canyon stage, and Bill DeVoss handles the ribbons on the down-canyon one on the right. Both men were well known for their skill as drivers. John Lilly stands by the front wheel of the coach. The Half-Way House served beer, and passengers could stretch their legs and eat a sandwich while tired teams were switched with fresh ones. The house was torn down for the war effort during World War II. (Eldora Community/ Bolton Collection.)

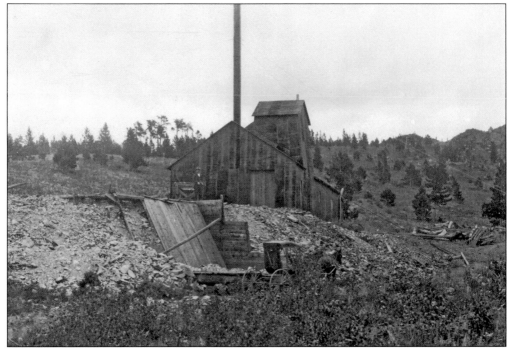

During the summer and fall of 1900, Nelson "Nels" D. Wanamaker and his son Clyde staked several claims in the Sherwood Gulch area. One of them was the Hoosier on Hurricane Hill. This photograph shows the Hoosier shaft house, one of the Wolf Tongue Mining Company properties, in 1909. (U.S. Geological Survey/photograph by F. L. Hess.)

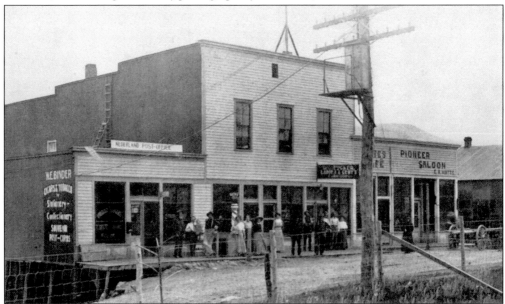

By 1900, W. E. Binder was Nederland's postmaster. His store on Main Street was also the post office, and he sold cigars, tobacco, stationery, confections, souvenirs, and postcards, like this one that featured his store. Next door was a barbershop, Tucker's Ladies and Gents store, a café, and the Pioneer Saloon run by C. R. Watts. (Author's collection.)

The Read, Wilson, and Beach families enjoyed outings at what they called Beach's Lake, which is today's Lost Lake. The lake was accessible by horseback or wagon on a road that passed through Eldora and Hessie. Here the families gathered in a tree along the banks of the lake for a photograph. (George and Sandra Breymaier, Berlin Center, Ohio.)

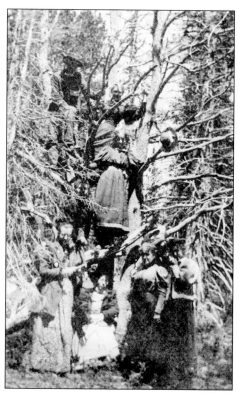

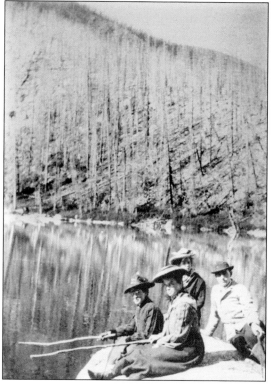

A great place to party was the lakes in the hills north of the Eldora camp. Fishing on Peterson's Lake was hard to get to, but the reward was beautiful scenery and delicious mountain trout caught on a homemade pole. Today skiers on their way to Eldora Mountain Resort pass Peterson's Lake just before they enter the ski area gate. (Eldora Community/Bolton Collection.)

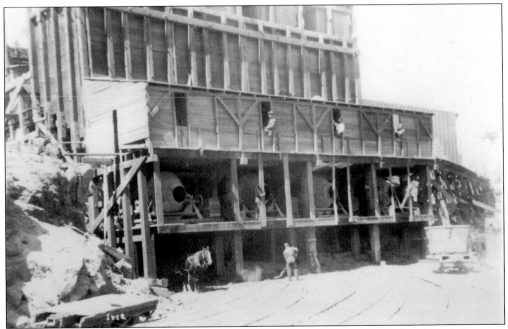

For the construction of Barker Dam, the Colorado and Northwestern Railroad hauled in two aerial tramways, a large sawmill, and a railroad-type steam shovel like the ones that had been used to dig the Panama Canal. The railroad built a 4-mile temporary spur line from Cardinal and Sulphide for the construction. Work on the dam was interrupted twice, once for the Panic of 1907, and again in 1908 for freezing weather. The dam and reservoir were named for Hannah Barker, who owned the ranch land in the meadow just east of Nederland that was flooded for the reservoir. The dam was part of the Boulder Canyon Project that brought water from Barker Reservoir to Kossler Reservoir and the hydroelectric plant in Boulder Canyon, which went into operation in August 1910. The city of Boulder purchased Barker Dam and Reservoir from Xcel Energy in 2001. (Nederland Area Historical Society Collection.)

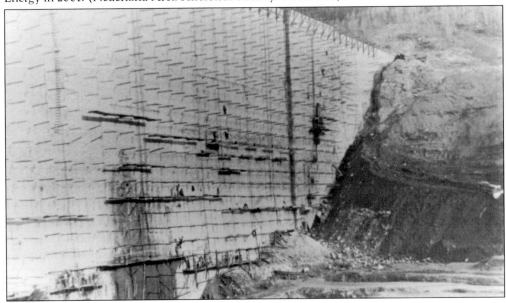

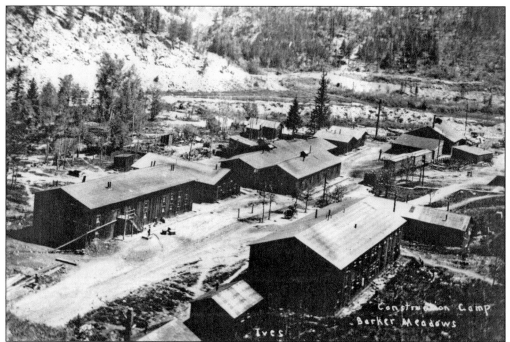

When Hannah Barker refused to sell her Nederland ranch land to the Central Colorado Power Company, which wanted to build a reservoir, the power company filed condemnation proceedings in district court. A jury decided in favor of the power company, and Barker received $23,000 for her ranch. During construction of the Barker Reservoir dam, workers lived in this camp on what had been Barker's hay meadow. (Nederland Area Historical Society Collection.)

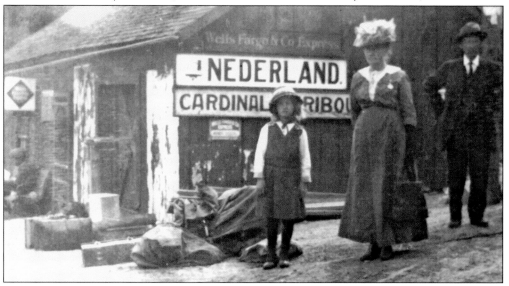

The train stop for Nederland was in Cardinal. From Cardinal, a daily stage line brought passengers east to Nederland, a mile and a half away, or west to Caribou, two miles away. The train left Denver at 8:00 a.m. and arrived in Ward at noon and in Cardinal at 12:14 p.m. Eldora was another 15-minute ride. The return trip left Eldora at 1:45 p.m. and arrived in Denver at 6:00 p.m. (Nederland Area Historical Society Collection.)

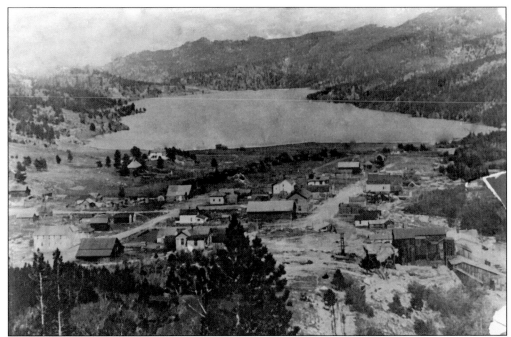

In 1911, some of the tops of the trees in the newly flooded meadow are still showing through Barker Reservoir waters. The Antlers Hotel sits on the hill just west of the reservoir, and the side of the Wolf Tongue Mill can be seen in the front right. The Hetzer Hotel is the two-story white building in the front left, just above the treetops. (Nederland Area Historical Society Collection.)

This view of the area between Nederland and Eldora in 1911 shows a low Barker Reservoir on the left and a road through the trees above the meadow. Archaeologists conjecture that this is where large numbers of Native Americans established base camps for game drives. (Courtesy U.S. Geological Survey.)

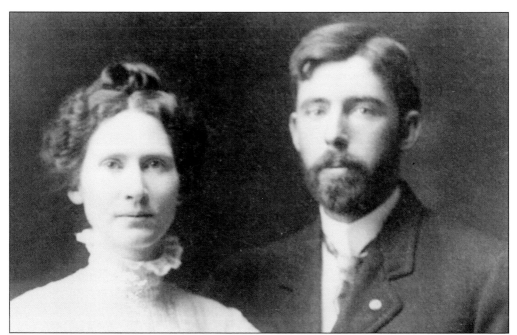

Dr. Carbon Gillaspie had an office and owned a drugstore in Nederland from 1905 until 1908. On Feb. 12, 1906, he traveled to Caribou in a bad storm to deliver a baby. When he returned to his carriage, his horse bolted and ran away, frightened by the long shadows cast by a lantern the baby's father, John G. Smith, had hung on the back of the carriage. Smith finally caught the horse, but Dr. Gillaspie was forced to walk the 4 miles back to Nederland through the blinding blizzard and darkness. He would not stay overnight, as he said that someone else might need his services. The baby, Hugh Smith, later lived in Boulder and was the tinner at Valentine Hardware store. The home that Dr. Gillaspie built for his wife and child is now the Gillaspie House Museum in Nederland. (Nederland Area Historical Society Collection.)

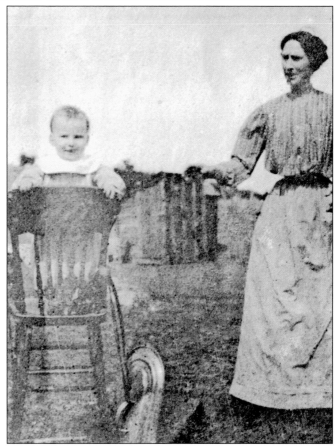

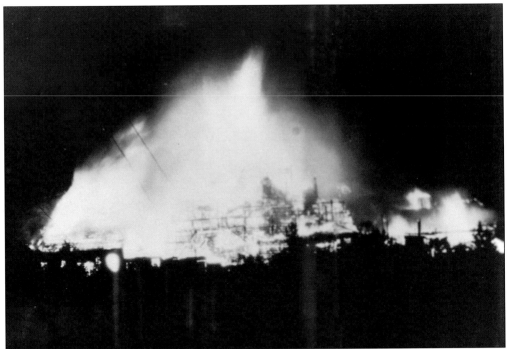

On July 3, 1926, the famous Wolf Tongue Mill burned down. Nederland residents mourned the loss of their old friend, and the Wolf Tongue quickly erected a new concrete, fireproof mill on the site. The new mill was designed for more modern methods of treating ore, and it continued operating under the management of W. G. Roseborough. (Nederland Area Historical Society Collection.)

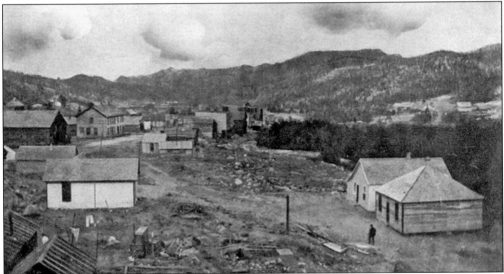

This view of Nederland taken from the Wolf Tongue Mill area looking east was published on a postcard by the Nederland Drug Company. It was labeled "The Tungsten Town." In 1900, Sam Conger, who discovered the first silver at Caribou, took some unfamiliar ore to Denver for analysis. The ore turned out to be tungsten, a rare metal, the source of another boom for Nederland. (Nederland Area Historical Society Collection.)

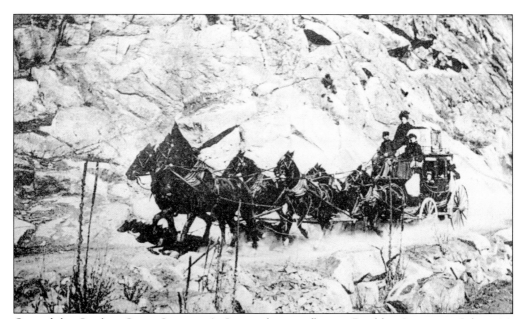

One of the Caribou Stage Company's Concord stages flies up Boulder Canyon in July 1906. In the early 20th century, Nederland was a stage stop on the Boulder-Caribou toll road and a regional supply and trading center. The four- or six-horse coaches carried 100 passengers daily. This photograph was the basis for a well-known painting by Dwyatt Fenn. (Eldora Community/Bolton Collection.)

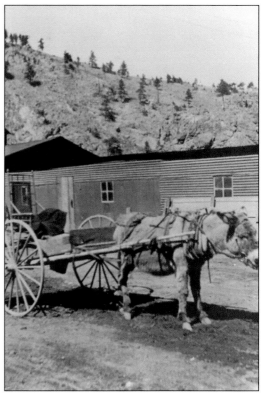

Burros were used for hauling carts, wagons, and buggies. They also were good pack animals, and hauled water, mine timbers, and supplies for the miners. They pulled ore buckets up from mines and pulled loaded ore carts out of mines. Nicknamed "mountain canaries" because of their distinctive braying, they were also called donkeys by people who loved them. The large-eared, small, but sure-footed animals can live 40 years. (Nederland Area Historical Society Collection.)

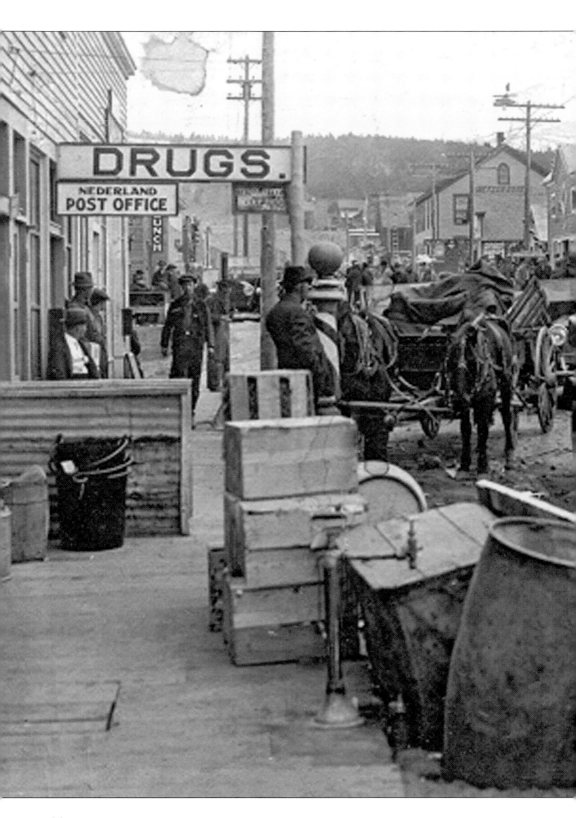

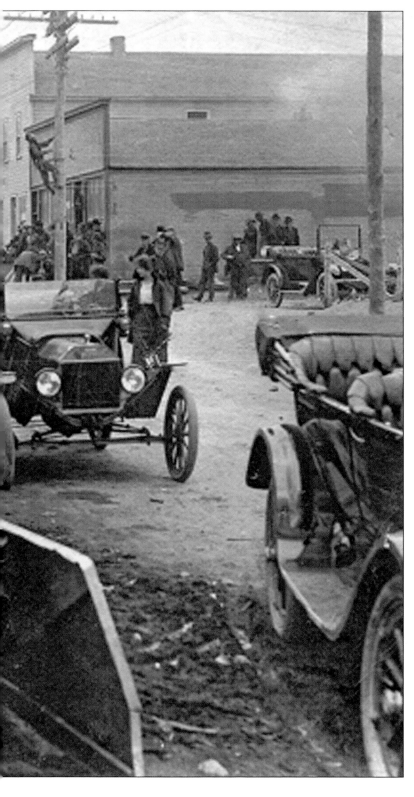

In 1916, Nederland was bustling with activity. Both automobiles and horse-drawn vehicles packed the dirt streets. The numerous motor taxis were offered to deliver prospectors to their claims, but often broke down from being overloaded and overheating on the rocky, narrow, steep roads. With a population of about 3,000, Nederland had a drugstore, post office, and a number of restaurants. Five hotels and several rooming and boardinghouses were all overflowing. Beds were rented in shifts all day and night. Outside town, tents and shacks housed thousands more. Nine new residential sections were added to the town in just one year, and construction hit an all-time high. Nederland was also the telegraph center of the county. Note the man climbing the pole in the rear center. (Nederland Area Historical Society Collection.)

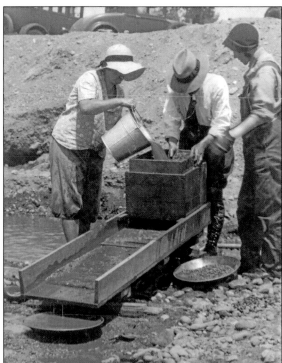

A bucket is used to pour water over the dirt in a rocker box in this panning operation. The box is rocked back and forth, and the riffles or bars in the sluice below force the gold to sink and separate from the other materials. (Nederland Area Historical Society Collection.)

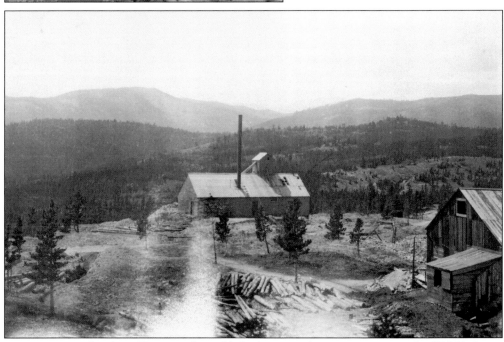

Sam Conger and Nelson Wannamaker sold the lease on their tungsten mine for $5,000. Later, Chauncey Lake, the manager of the Boulder County Tunnel, named the mine after Sam Conger. At a depth of 700 feet, the Conger mine was the largest producer of ferberite ore in Colorado. At one time, a few years after this photograph was taken in 1909, it was the world's largest tungsten producer. (U.S. Geological Survey/photograph by F. L. Hess.)

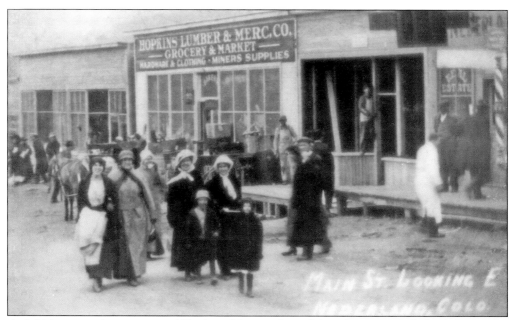

A. J. Valore was the manager of Hopkins Mercantile on Main Street in Nederland during the tungsten boom, from 1916 to 1918. He later moved to Littleton and opened Valore Hardware. The sign says "Hopkins Lumber and Merc. Co.—Grocery & Market—Hardware & Clothing—Miners Supplies." Two doors down are a real estate office, laundry, law office, and barbershop. (Mary Wingate collection.)

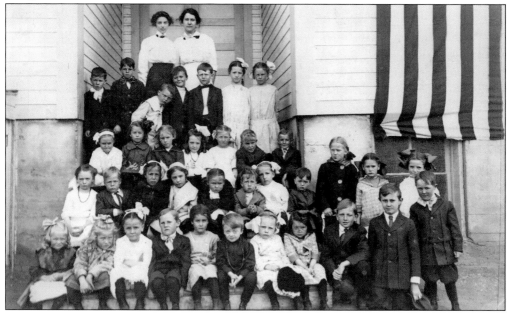

In September 1917, Miss Dryden and Miss Rupert taught the first two grades at Nederland School. They had 35 and 33 pupils respectively. In 1918, there were nineteen girls and nine boys in the third grade, and five boys and two girls in the fourth grade. The following year, enrollment stood at 183, and six teachers handled the classes for first grade through high school. (Nederland Area Historical Society Collection.)

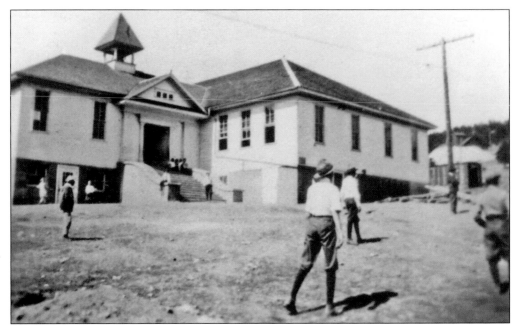

By 1870, Nederland had a school, and five years later there were 30 to 35 pupils enrolled under the instruction of B. T. Napier, a handsome young man from Missouri who was a favorite of the older girls. School was held in the summer from May to October. About 1907, a new two-room school was built, but it burned down three years later, and the town voted a bond to build a new modern four-room schoolhouse to replace it. The new building was completed in 1911. Two rooms were added in 1916 (above). In 1921, four years of high school were established, and lavatories were installed. Gradually, Nederland absorbed the surrounding districts of Glacier Lake, Lakewood, Caribou, Tungsten, and Eldora. In 1936, the town approved a bond issue, which, with the aid of WPA funds, built a gymnasium, three classrooms, one fully equipped science room, and a library. (Nederland Area Historical Society Collection.)

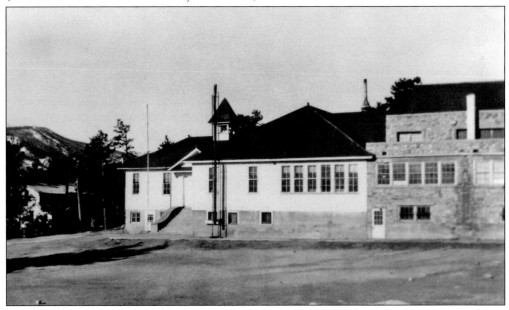

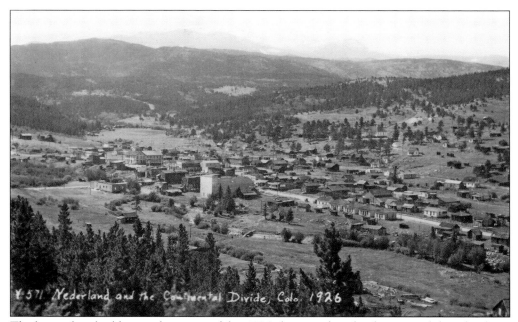

The large white building in the center of this 1926 photograph is the theater, and the other large white building with lots of windows is the Hetzer Hotel. The small look-alike buildings in a row are probably tourist cabins. The white building on the hill in the upper right center is the school. (Nederland Area Historical Society Collection.)

Model Ts, like the one shown here in the background, had to back up hills. The gas tank was under the seat, and they had very little power going forward uphill, so the usual method of getting around in the mountains was to back up when the hill got steep. (Jimmy Griffith collection.)

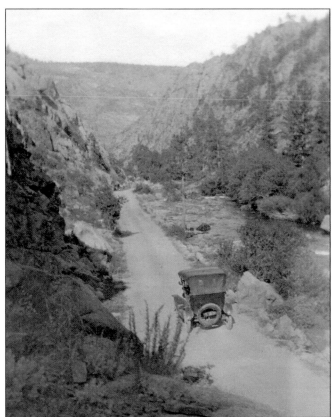

After Boulder County took over the road between Boulder and Nederland, the county gradually widened and improved it, getting rid of the corduroy sections. But until 1913, it was still very steep and treacherous. From 1913 to 1915, prisoners from Cañon City worked on the road, widening it and giving it a better grade. (Nederland Area Historical Society Collection.)

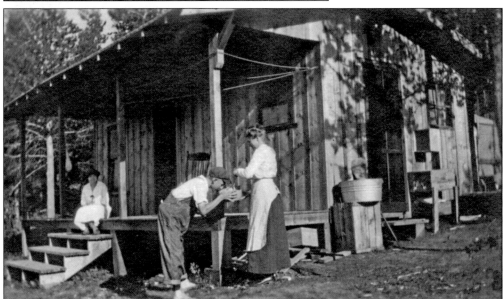

On a hot summer day in August 1917, Mary Valore helps her son Richard get a drink of water at the one-room house the family used while Richard's father managed Hopkins Mercantile in Nederland during the tungsten boom. With a touch of irony, they named the small house Casa Grande. (Mary Wingate collection.)

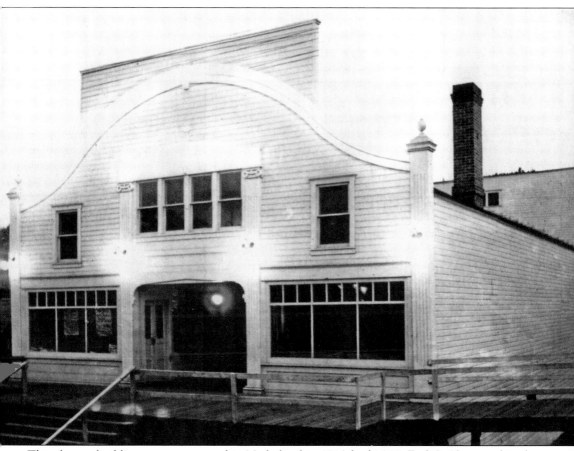

This theater building was constructed in Nederland in 1916 for $9,000. Earl G. Platt was hired for the construction. As you entered the building, the theater offices and ticket counter were to the right. To the left was an ice cream parlor that sold candy and popcorn. The "show house" was handsomely outfitted with 650 upholstered seats on a sloped floor, a stage, dressing rooms, a deep-red velvet curtain (the plans called it an asbestos curtain), and cushioned wooden seats. Part of the lobby and the all of the theater walls were covered with murals depicting the region's natural features, painted by a woman artist from Boulder. The theater showed at least two movies a week and hosted Vaudeville stage shows. The building also housed community events and school graduation ceremonies. In 1935, a young boy put a match to the building, and it went up in smoke. Fortunately it was unoccupied. (Nederland Area Historical Society Collection.)

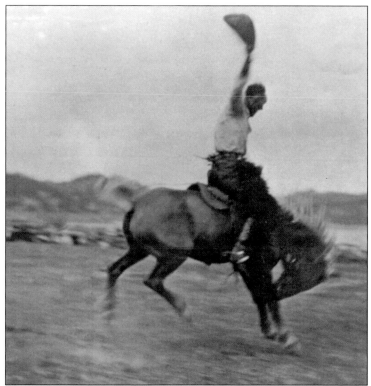

Fourth of July in Nederland was a time for celebration. Traveling rodeos came to town, and here cowboy George LeFevre entertains the crowd by riding bucking bronco "All Off" in 1916. The rodeo was held in the meadow along the western shore of Barker Reservoir. (Nederland Historical Society Collection.)

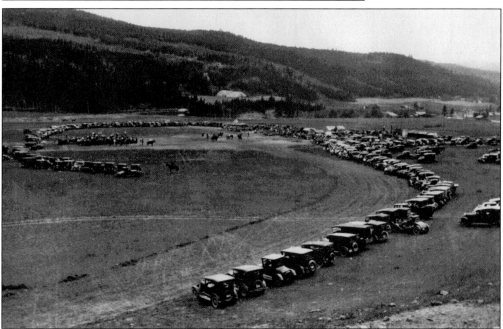

During the 1920s, Jim Sewell, often known fondly as "Whoopee," was the promoter of local rodeos in the area just west of the reservoir in Nederland. The event usually took place over the Fourth of July holiday. People sat in their cars since there were no bleachers. (Nederland Area Historical Society Collection.)

A traveling show brought this extraordinary ladder and a large tub of water to the Fourth of July celebration in a booming Nederland in 1916. Spectators dressed up to watch J. D. Mabee, "Colorado's Expert Diver," climb the ladder and dive into the tub of water. The building behind the ladder advertises "Rooms and Board." (Nederland Area Historical Society Collection.)

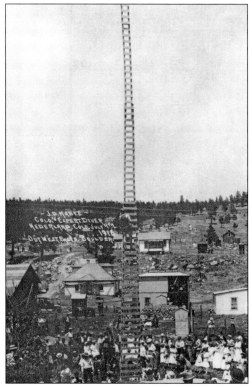

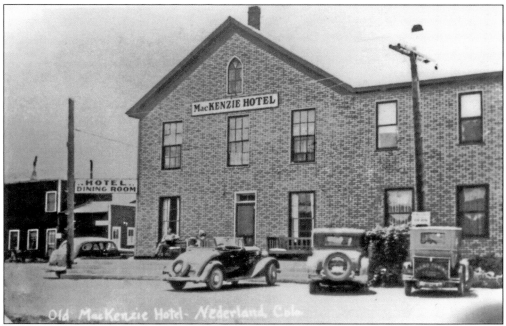

Neil D. McKenzie and J. Wesley Hetzer owned the Poorman Mine and a mill at Caribou together during that town's boom, and years later, the MacKenzie family bought the Hetzer Hotel and resided in it. This photograph was taken on the day the piano tuner had arrived. The hotel burned to the ground in 1940. (Nederland Area Historical Society Collection.)

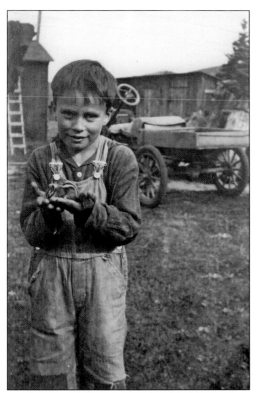

A young Jimmy Griffith holds a chipmunk for the camera. Griffith was born in the house his father, the town marshal, built on the road that eventually became Griffith Street. Griffith started out working in the mines, and then he became the town marshal, street commissioner, water superintendent, and cemetery caretaker. He and his wife, Vera, used to sit on the porch of the drugstore, and people called them "Matt and Kitty" after the characters in the television series *Gunsmoke*. (Jimmy Griffith collection.)

Cowgirl Goldie Griffith Cameron moved to Nederland in the early 1920s. Griffith performed with Buffalo Bill's Wild West and ranched with her second husband, Tim Cameron, at the Tucker Ranch. Later, Cameron served as marshal, and Griffith opened several restaurants. Here, she and the Roose brothers check out some mining memorabilia. (Author's collection.)

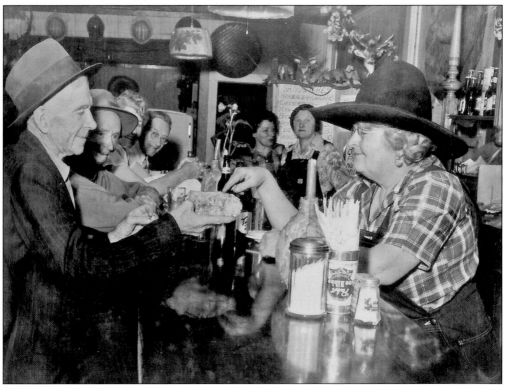

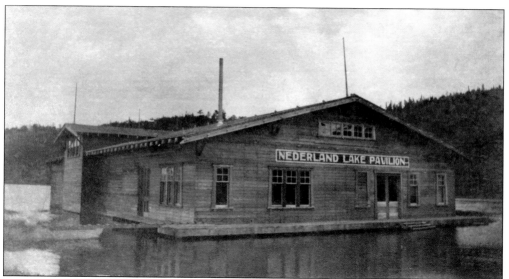

Nederland always has been a dancing town. In the late 1800s and early 1900s, the town orchestra consisted of Cal Peterson and Mr. Leming, who played fiddles. Oren Beach called off the quadrilles. In 1936, the Flarty orchestra was organized. Dances were held regularly in this pavilion, built by George Baker, Edward Goldberg, and Edward Yates, with a floor of quarter-sawn oak suspended on springs out over the water of Barker Reservoir. (Goldie Cameron/Sterling family.)

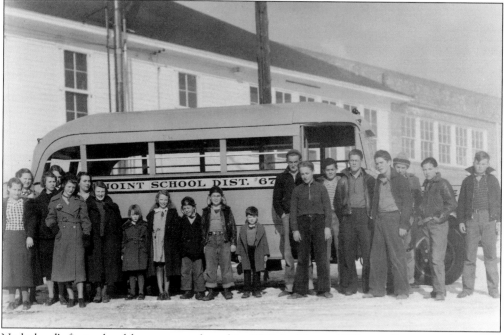

Nederland's first school bus was purchased in 1937. In March 1939, enrollment in the school was 166 in first grade through high school. W. E. Smith served as superintendent; Pearl Clark taught advanced English and commercial; R. A. Moorman, music; J. F. Schlegal, athletics and science; A. H. Dolph, high school; Sterling Gilbert, fifth and sixth grades; Floy Mitchell, third and fourth grades; and Margaret Johnson, first and second grades. (Nederland Area Historical Society Collection.)

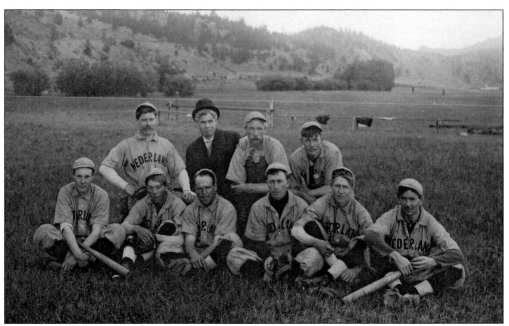

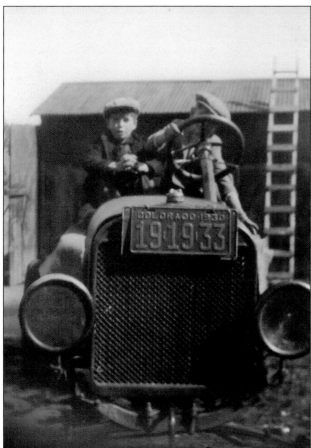

One of Nederland's pastimes was watching baseball, and here the town team takes a time-out for a photograph in Hannah Barker's meadow. The man in the black suit is Wallace Tanner, who opened the Tanner Brothers Grocery in 1905 with F. M. Mathews and Ed DeKraker. The store operated for a number of years under various owners and names. Tanner also was a director of Nederland's first bank, which opened in 1915. (Jimmy Griffith Collection.)

Two kids play in what is left of a car with a 1930 license plate. Through the years, the young men in town also organized a basketball team. Other recreation included bowling, dancing, and wrestling bouts. From 1907 to 1915, the town had a band of 50 members led by a one-armed man named Stephens. The band toured the mining towns and played in Boulder and Denver for different organizations. (Jimmy Griffith Collection.)

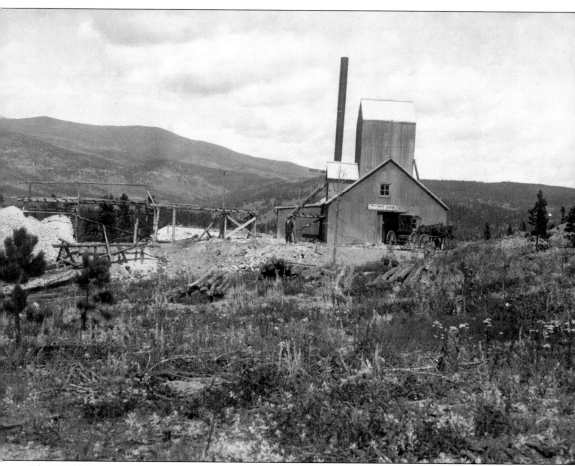

The Wolf Tongue Mining Company was incorporated in 1904. The company bought the old Caribou mill at Nederland, and it also bought and operated numerous mines in the area. Its name came from the two words wolframite and tungsten. The company expanded quickly. In one transaction, on February 17, 1906, A. G. McKenna, a metallurgist and chemist for the Firth Sterling Company, the largest user of tungsten in the United States, bought the J. T. Trevarton ranch, presumably for the mining company, for $12,000. The ranch was in the center of several good tungsten veins, and McKenna paid another $20,000 for 18 claims on the ranch northeast of Nederland in the Gordon Gulch region. Among those claims was the Cold Spring, which opened in 1908 and became the Wolf Tongue's richest producer of tungsten. The company's Town Lot shaft house, Shaft No. 2, is pictured here on September 3, 1909. (U.S. Geological Survey/photo by F.L. Hess.)

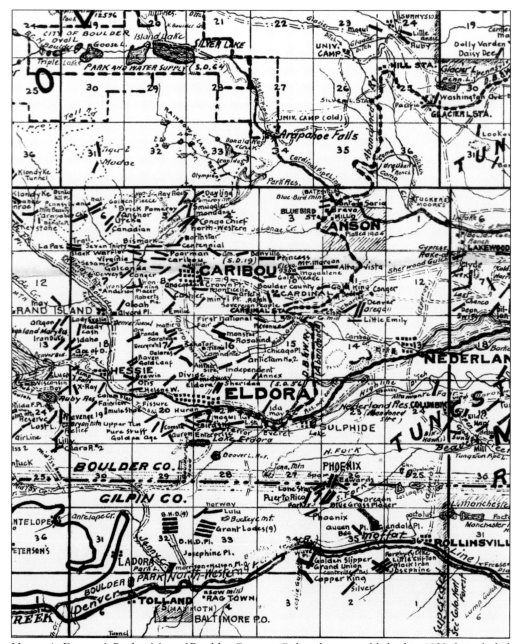

Henry A. Drumm's Pocket Map of Boulder County, Colorado, was published in 1932. It included a description of the county dated 1925. Although not accurate by today's standards, the map is useful for locating long-gone mining camps and mines. (Author's collection.)

Two

CARIBOU

Sam Conger is credited with the discovery of silver at Caribou. In December 1869, Conger, William Martin, and George Lytle filed a claim, and by spring, the word was out about the "belts of rich silver ores" in the mountains north of Central City and west of Boulder. A camp sprang up as miners arrived, and at an altitude of 10,000 feet, it was one of the highest, coldest, and windiest camps in Colorado. That first year, it was heavily forested. Soon, the forest was gone, replaced by mine and mill buildings, tailing piles, and a town.

A better road to the town site was completed in 1871, and stages began arriving with passengers and mail. The Caribou Stage Company operated a line of Concord coaches and during inclement weather brought passengers up from Nederland on a sleigh.

In its first years, the thriving community had 60 businesses and 400 people, supported by 20 producing mines. At its peak, Caribou was home to 3,000. The town trustees, who were usually businessmen, dealt with water works, the sanitation system, and the surplus of dogs. Businesses included billiard halls, saloons, hotels, general stores, a meat market, a shoemaker, and a newspaper, the *Caribou Post*. Winters in Caribou were harsh. One story told of a Swede who arrived from Minnesota to work in the mines but soon quit, muttering that the region had "nine months of winter and three months of late fall."

In 1879, the first of three fires swept through Caribou, and, although 40 to 60 homes and mine buildings were lost, the center of town survived, and Caribou rebounded. A telephone line was extended to the town in 1881, but it could not bring help quick enough to save the premiere buildings, which were lost in a second major fire in 1899. The silver crash of 1893, along with epidemics of scarlet fever and diphtheria, led the downhill slide of the once-rich mining camp, and a third fire in 1905 further decimated the town. After 35 years of glory, hardly anything remains of this important mining camp in Colorado history.

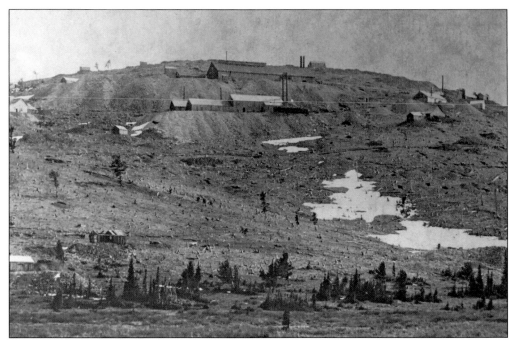

Silver was discovered in Caribou in 1869 by Sam Conger, a hunter, prospector, and miner. Prospectors and miners descended on the site by the hundreds and soon the hills were bare of trees. The Caribou, Belcher, Sherman, Poorman, and No Name mines were all big producers for Caribou, and the Caribou was acclaimed the richest silver mine in the world. (Nederland Area Historical Society Collection.)

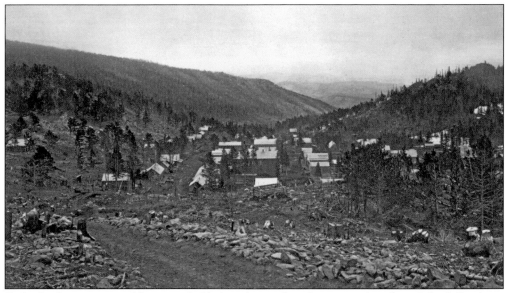

Early Caribou is pictured here nestled below the road to the mines that dotted the hills above the town of 300 inhabitants in 1873. Stories of the "richest silver deposits on the Continent" brought adventurers by the hundreds to the new camp near timberline. George Lytle, who had mined in British Columbia, gave the mining camp its name. (U.S. Geological Survey/photograph by W. H. Jackson.)

Many of the miners in Caribou came from Cornwall. The 1880 census reported that 60 percent of the miners in Caribou said they had been born in the British Isles, where they, or their fathers, had been miners. The hardworking Cornish were said to be the "best class for this business that could be obtained." They are also credited for the sturdy rock walls, many of which still stand in the region. (Nederland Area Historical Society Collection.)

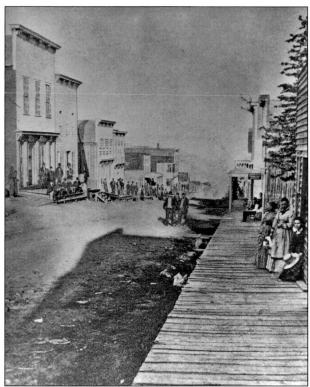

Potosi Street was the main street of Caribou. The large building on the left is Pete Werley's saloon. The Sears and Werley Billiard Hall and Saloon was the largest building in the community, with "three good tables" and offices on the second floor. It was lathed and plastered throughout. On the right, the building with the balcony is Murphy's meat market. At its peak in 1875, Caribou had about 3,000 residents. (Nederland Area Historical Society Collection.)

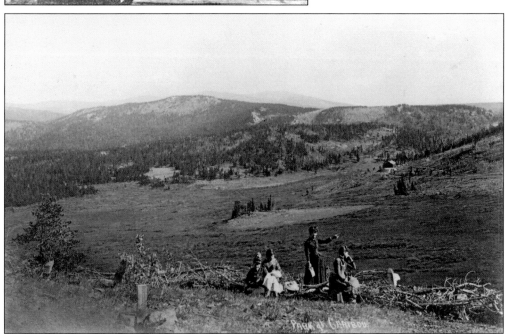

The residents of Caribou enjoyed roller-skating at the rink, dances, parties, and picnics. Old-timers remembered, "right in the middle of the picnic, though, it might begin spitting snow. It was a wintry place year around." Women picked raspberries, strawberries, currants, and huckleberries and canned them. (Nederland Area Historical Society Collection.)

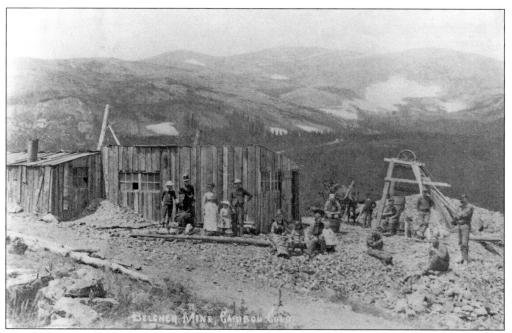

The Belcher Mine at Caribou was leased by the Irwin brothers, Joseph and William, as early as 1884. They later bought the mine and sold it in 1887 for a reported $100,000. The new owners and their lessees continued mining the Belcher into the 1890s, which may be when this photograph was taken. (Nederland Area Historical Society Collection.)

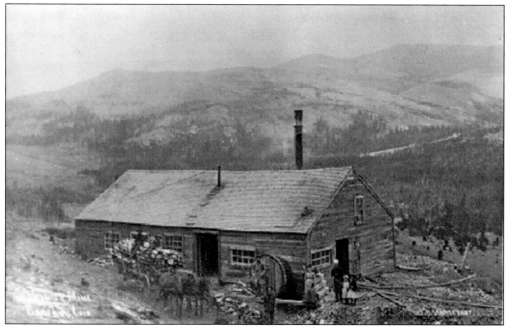

A family with two young girls stands next to the corner of this mine building in Caribou on a day when a load of cordwood is being delivered. The big mine operations at Caribou consumed enormous amounts of wood for heat and to power the machinery; loading and hauling the wood took a lot of skill. (Nederland Area Historical Society Collection.)

This photograph of a row of typical miners' homes was taken on a day when laundry was hanging out to dry. Women in the camp found that when the peddler's wagon came to town every week in the summer with fresh vegetables, melons, and fruit, it was best to meet him below town before he sold out to the boardinghouses. (Nederland Area Historical Society Collection.)

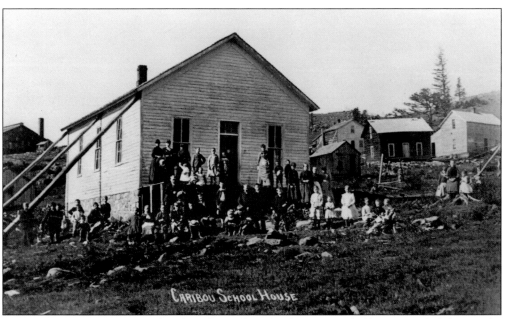

Winters in Caribou were too harsh to keep the school open, so children attended during the three months of summer. When Miss Allen arrived from Nebraska to take over as teacher, she and the foreman at the Pandora mine, a big, tall handsome Irishman by the name of Jim Butler, fell in love. On their wedding night, the local kids climbed up on the roof of their house, stuffed gunnysacks down the chimney, and smoked them out. "Then we gave them a real charivari," one of the students recalled years later. (Nederland Area Historical Society Collection.)

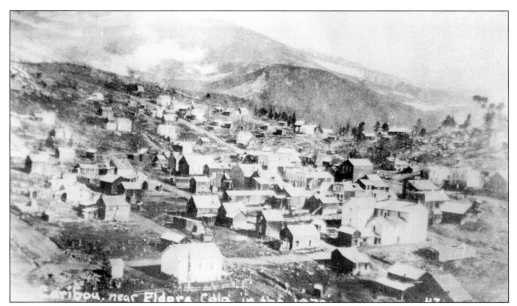

The 1870s was Caribou's most prosperous decade. At times, construction crews could not keep up with the demand for housing as miners arrived by the hundreds, and some were forced to live in lodges made of a few poles laid over a gap between two large rocks. Two commercial streets competed for business, with multiple-story frame buildings complemented with false fronts and boardwalks that stepped up the steep hill. (Eldora Community/Bolton Collection.)

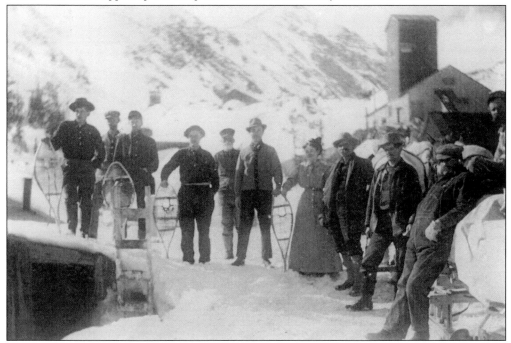

On a rare day without wind, a group poses for a photograph with their snowshoes at a shaft structure. Caribou was known as the place where "the winds were born." Newcomers quickly learned to plug their keyholes with a rag at night, or they would wake up in the morning to a drift of snow inside the house. (Nederland Area Historical Society Collection.)

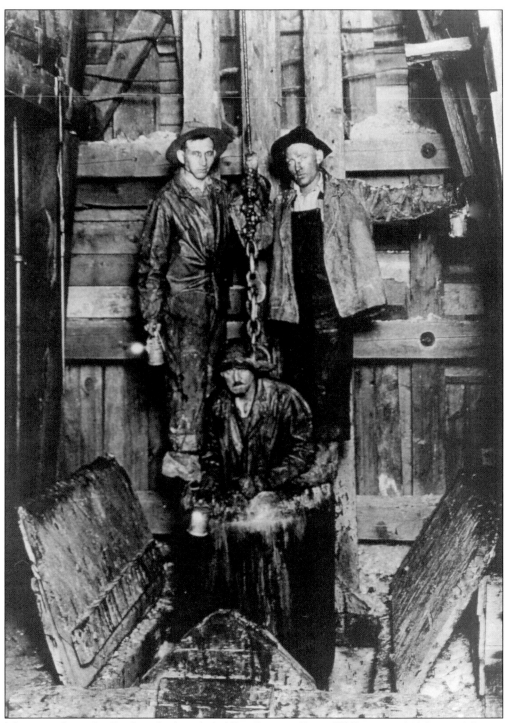

Miners working the Caribou shaft included Ray Betasso, Foster Williams, and ? Morton. Mining was dangerous work, although Caribou was safer than many other Western mining districts. In Caribou's early days, the miners worked from dawn to sundown, and much of the labor was done by hand. (Nederland Area Historical Society Collection, Ed Tangen photograph.)

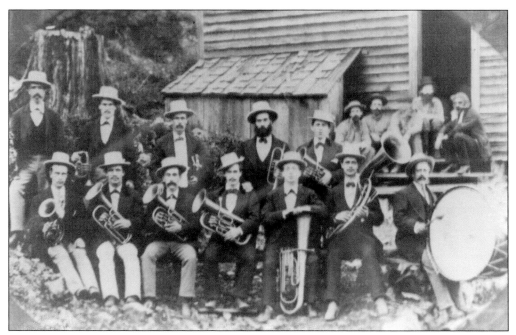

The Cornish are well known for their love of music, and about half of the members of the town's brass band were from Cornwall. The band played at Christmas and New Year's Eve balls, serenades, and weddings. They traveled to surrounding communities to give concerts and always received complimentary reviews. (Nederland Area Historical Society Collection.)

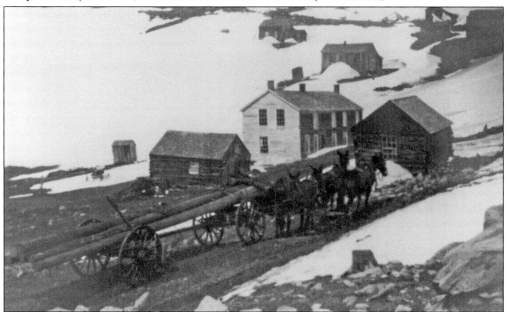

Some winter days were mild enough that teams hauling loads of timbers could negotiate the roads. But for the most part, wind and snow could isolate the camp for weeks, and snow filtered into houses through cracks and drifted against doors, trapping residents inside. When the wind blew in Nederland, the joke was that someone must have left a door open in Caribou. (Nederland Area Historical Society Collection.)

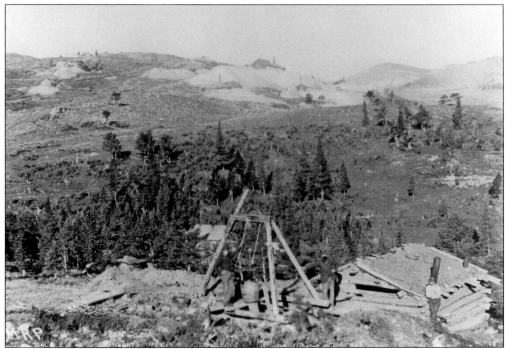

A hoist and a bucket brought ore up from the shaft below for this mining operation. In the background are Caribou's big mines and mills. The roof of Todd house is visible just to left of the hoist. William Todd was a teamster turned saloon keeper who also occasionally treated gunshot wounds, set bones, and helped pull teeth. (Nederland Area Historical Society Collection.)

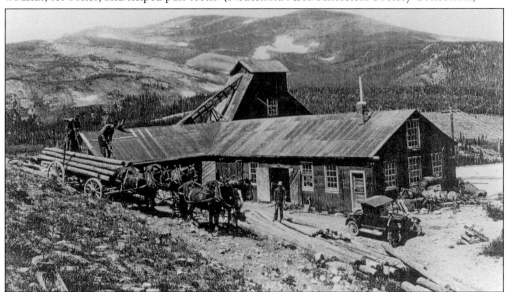

Views from the Caribou Mine were spectacular. Even after automobiles could negotiate the steep, rutted, and often muddy roads to Caribou, timbers were still hauled by horse and wagon. Veteran miner Jack Clark leased various levels of the Caribou Mine in 1918. During the next five years, it is estimated that the mine produced about $300,000, and work continued throughout the 1920s. (Nederland Area Historical Society Collection.)

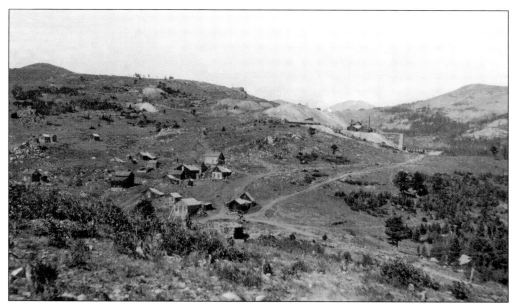

A fire on a windy day in November 1905 destroyed most of what remained of Caribou, sparing only some of the major mining buildings and a few houses. Only one general store, a postmaster, and a population of 25 remained when the photographer took this picture looking west from Boulder County Hill in 1911. (U.S. Geological Survey/photograph by E. S. Bastin.)

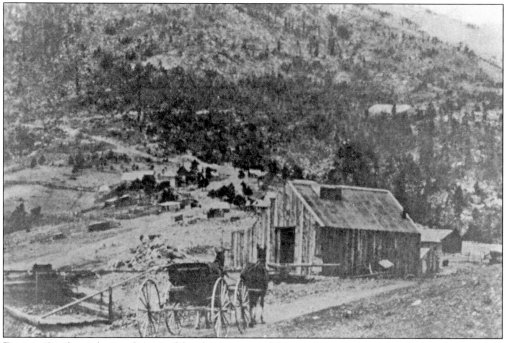

During Caribou's boom, buggies like this were used for transportation around town for many of the town's business professionals and others. Caribou did not have many lawyers, but it did have several doctors. Among them was Dr. William Mann, who came to Caribou about 1871. The miners agreed to withhold $1 a month per man from their wages to serve as a retainer to keep the doctor in town. (Nederland Area Historical Society Collection.)

After the toll road from Boulder to Caribou was completed in 1871, the mail route was shifted from Central City to Boulder. Stages carrying mail arrived daily during the camp's most prosperous years. Later, mail carriers brought the mail from Nederland, although at times it was delayed for weeks due to winter storms. By 1938, the post office, which closed in 1917, was one of the last buildings standing in Caribou. (Eldora Community/Bolton Collection.)

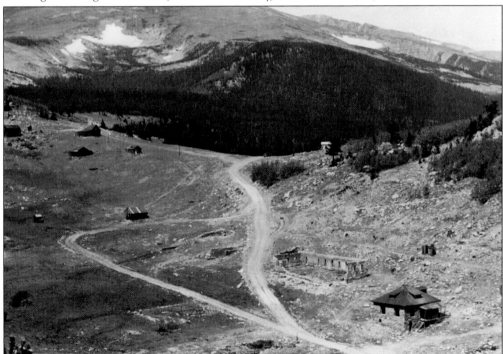

By the mid-20th century, only a few buildings remained in Caribou. According to historian Isabel Becker, the first stone ruin was originally the Leo Donnelly general store, rebuilt in 1928 as a rooming and boardinghouse by the Potosi Mining Company. The other stone ruin started out as the two-story Sears and Werley Billiard Hall. (Nederland Area Historical Society Collection.)

Three

ELDORA

Although John H. Kemp located the Happy Valley placer claim in 1891, it was not until 1897 that a mining camp was born. Eldora's big mining boom followed for a short two years. The community first took the name of Happy Valley. Later, as it grew, it took the name Eldorado, but after mix-ups in mail delivery, it became El Dora and then Eldora. Geologically, Eldora's mines were in a sulphide belt, and the prospects seemed good for making fortunes. Forty to fifty newcomers a day disembarked from the six daily stagecoaches, and a place to sleep was often hard to find. Even saloon floors were covered with sawdust and rented out. By early January 1898, the population had swelled to 1,300. Prospectors swarmed over the nearby hills. Businesses flourished, including 11 saloons, and a red-light district called the Monte Carlo Addition.

Many of the mines had started to experience hard times around the early 20th century, and it was hoped the extension of the railroad to Eldora would provide the solution. By late 1904, the Colorado and Northwestern Railway had laid tracks from Sunset, around Sugar Loaf Mountain and Glacier Lake, ending in Eldora. Operations began on New Year's Day 1905. But the railroad could not save the mines, and they continued to close. Eldora's businesses began to rely on the tourists who rode the train on "wild flower excursions" to the "grandest panoramic view in the world." Visitors flocked to the scenic town, and from there they hiked or rode horseback to the high-mountain lakes, nearby peaks, and Arapaho Glacier. But then the railroad too was gone. A huge flood washed out its tracks in the canyons west of Boulder in 1919, and it did not rebuild. Soon the automobile took its place, bringing sightseers to the scenic valley.

In 1989, the Eldora Historic District was placed on the National Register. Today Eldora is a close-knit community of people who cherish its history. And it is still on the road to popular recreation areas.

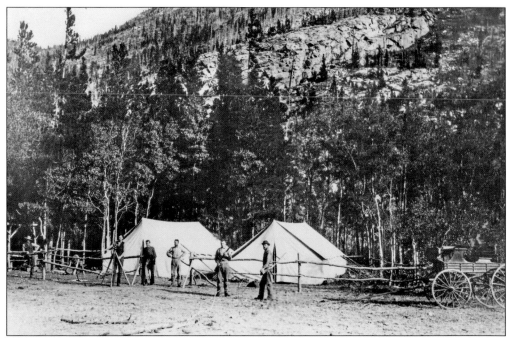

John H. Kemp and seven associates from Central City laid claim to about 500 acres along Middle Boulder Creek on September 5, 1891, and surveyed it for a town site. A. M. Thomas of Central City took this photograph of the Happy Valley Placer Company, just west of today's Eldora, about 1892. Kemp is leaning on the fence at left. Engineer August Mathez stands behind the transit. (Eldora Community/Bolton Collection.)

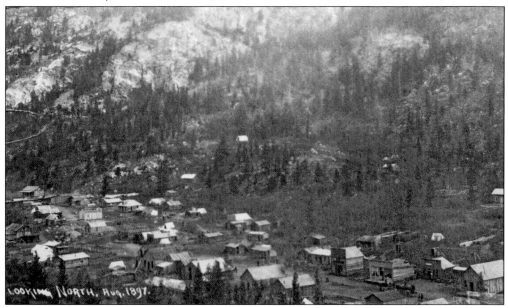

In August 1897, Happy Valley's name had been changed to El Dora, and numerous new residences and businesses with stylish false fronts were under construction. Where previously there had been only a few miners' cabins, a town had sprung up, which by the late 1890s had a population of about 1,000. (Eldora Community/Bolton Collection.)

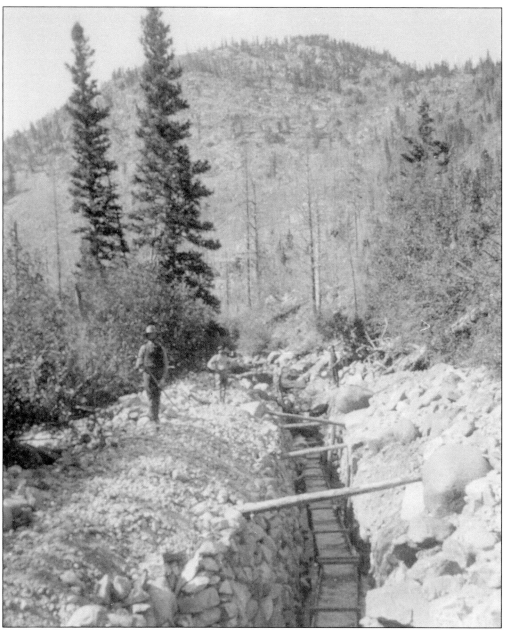

Much of Eldora's gold was found in surface ore. John H. Kemp, a mine operator from Central City, staked the Happy Valley Placer in 1891. His first headquarters was in two large tents, which later served as temporary kitchen, dining room, and sleeping quarters for laborers when the headquarters was moved down the valley. A hydraulic giant tore tons of placer gravel from the stream bank, which was washed through long sluices equipped with riffles in which mercury caught and held the flakes and nuggets of gold. The output of gold from this operation was never great, but it did fan the hopes of miners starting to arrive in the region. These four men were working the Happy Valley Placer sluice box in 1894. Placer mining in Happy Valley was abandoned about 1899, and most of the metal in the flume structures was carried away for the war effort in World War II. (Eldora Community/Bolton Collection.)

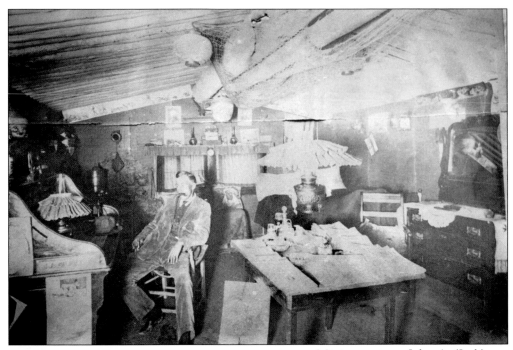

Mining engineer John A. (Jack) Gilfillan came to Eldora from Caribou in 1889. He and a partner staked the Clara mine and built a log cabin to live in. Not long after, Gilfillan built another spacious one-room cabin with a kitchen, dining room, and living room at the foot of the mountain and across the creek. His decor included lots of pictures clipped from magazines, doilies on the furniture, and a tennis net festively hung from the ceiling. Gilfillan eventually moved his cabin a few hundred yards north. He numbered each log before dismantling the old cabin. He also worked as the engineer at the Mogul Tunnel, and he often sat on his tiny veranda, looking down at the town he had helped create. One old-timer remembered that Gilfillan left the valley in 1910, married, and started farming near Platteville, Colorado. (Above, Eldora Community/Bolton Collection; left, Nederland Area Historical Society Collection.)

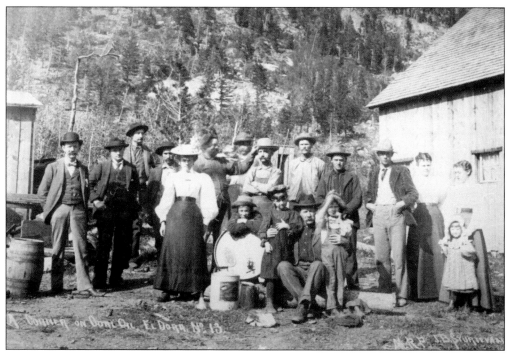

As miners and settlers arrived in Happy Valley, they decided to take on the name Eldorado Camp. But when their mail, including the payroll for the Terror Mine on Spencer Mountain, was mistakenly sent to the California camp with the same name, residents decided to drop the last syllable of Eldorado, and the town became El Dora and then, finally, Eldora. (Eldora Community/Bolton Collection.)

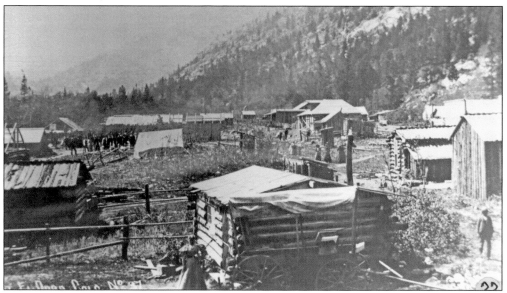

Tents, log cabins, and frame commercial buildings all were being constructed as quickly as possible as El Dora began to grow. During its two big boom years, 1897 and 1898, construction was at an all-time high. Here, a woman stands next to her canvas-topped wagon, and groups of men and women pose in the background. (Nederland Area Historical Society Collection.)

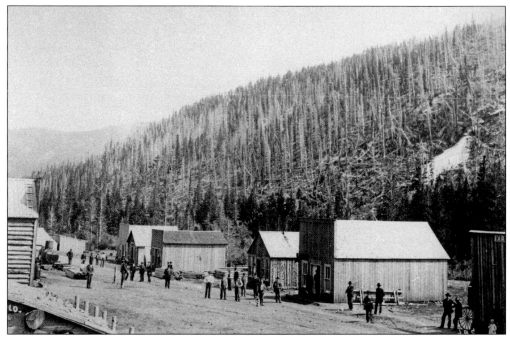

On this day in 1897, mining equipment has arrived on a bustling main street lined with proud, false-fronted buildings. As Eldora boomed, it became a principal source of supplies for the nearby mines. Piles of logs are ready for erecting another building, and men have stopped their work momentarily for a photograph. The town was platted and incorporated on March 9, 1898. (Eldora Community/Bolton Collection.)

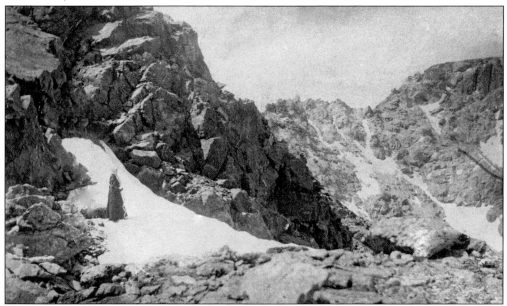

Although the glacier is smaller today, the scenery is basically the same as it was when this woman arrived, with her walking stick, at the top of Arapaho Glacier just below the summit of Arapaho Peak. Arapaho Glacier was a popular tourist destination, and several services led hikes and horseback rides to see the perpetual snowfield. (Eldora Community/Bolton Collection.)

After Dr. Harold Martin and his new wife honeymooned in Eldora, they decided to settle in Denver, where he was an osteopathic physician. They acquired a cabin in Eldora in the 1920s. Clara Miller poses for a photograph in front of Dr. Martin's house. (Eldora Community/Bolton Collection.)

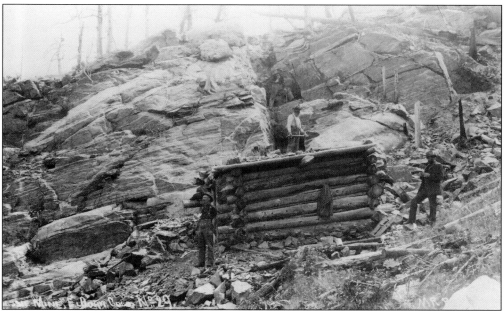

Written under this photograph of the Jessie mine is "Worldly Hopes Spencer Mountain 1897," probably an apt description of the aspirations of these four men who are working the mine. By 1897, they were just four of many who had come to the Eldora valley searching for their fortunes. (Nederland Area Historical Society Collection.)

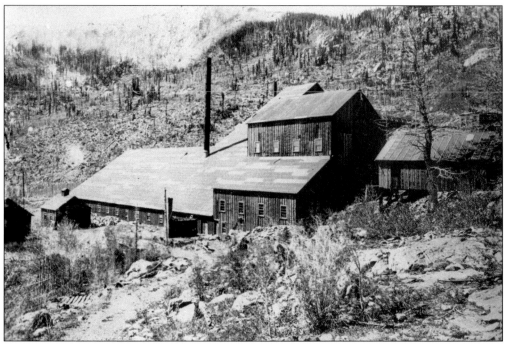

Neil B. Bailey, president of the Bank of Eldora, built a big mill at the foot of Ute Mountain. Shown here are the men who worked on building a log-cribbing dam that drew water from the creek. The water traveled down a wooden flume to the mill, where it turned the turbine that powered the machinery. Unfortunately, the mill's chlorination process was not suited to Eldora's ores, and Bailey's financial backer died suddenly. When Bailey could not meet his payroll in November 1899, his employees got drunk and demanded payment. They set fire to Bailey's house, and when he tried to put it out, they shot him in a hail of bullets as his family lay prone on the floor. Bailey died a few days later from an infected gunshot wound in his arm. No one was ever punished for the crime. (Eldora Community/Bolton Collection.)

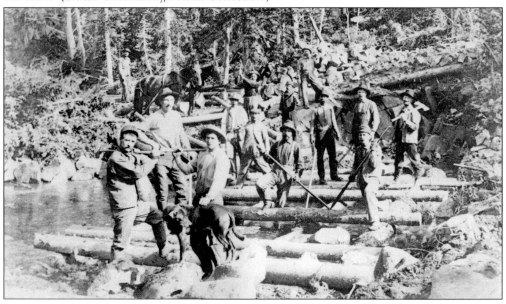

Cashier Ralph Balch works at the window in the bank at Eldora. Behind him is the vault. Eldora's mushrooming population made opening a bank feasible. In addition to the bank, the town boasted a photographic gallery, a free reading room, a cornet band, a newspaper, several boardinghouses, and 11 saloons. The bank building is shown below in 1901. (Eldora Community/ Bolton Collection.)

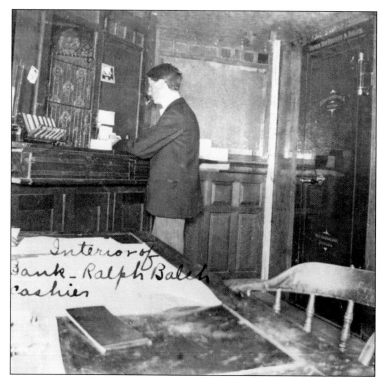

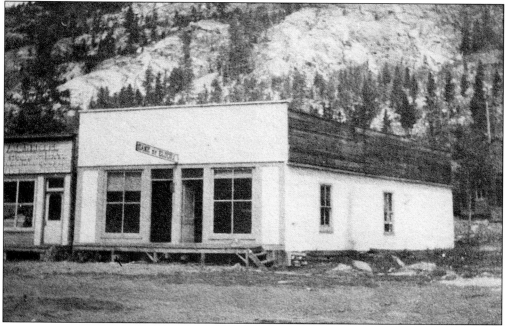

While the photographer was at the bank in 1901, bank employees set up a playful shot with cashier Ralph Balch seated on the floor and another worker appearing to doze off, both with lit cigars. At least two of the women were caught laughing at their antics. (Eldora Community/Bolton Collection.)

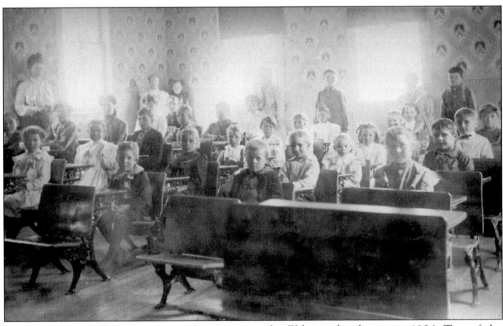

Students in one of the four large classrooms in the Eldora school pose in 1906. Two of the classrooms were on the second story and two on the first. In addition to classes, the school hosted entertainments, including programs put on by the students that included recitations, drills, and songs. (Eldora Community/Bolton Collection.)

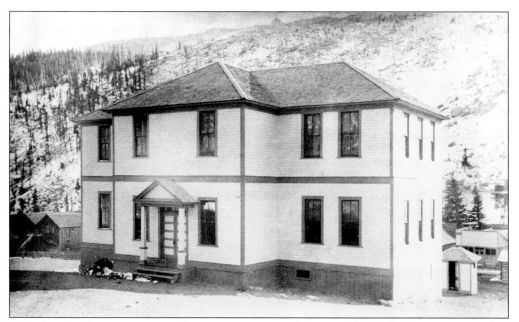

Eldora's schoolhouse was a grand structure as pictured here in 1901. It had two stories with a basement where wood and coal were stored. Two multi-hole privies of similar architecture to the school stood on the south side. The white building with green trim was torn down for lumber to build some cabins in Eldora around 1940 or 1942. (Eldora Community/Bolton Collection.)

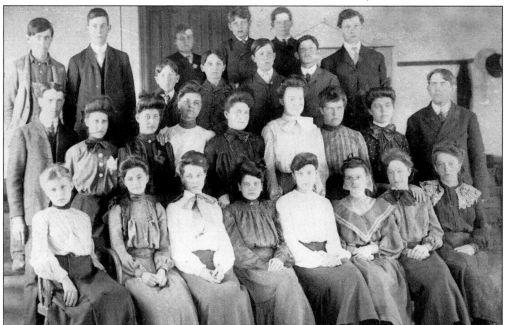

Around 1900, the graduating class at Eldora School included 27 students. As the area's towns began to decline in population after the mining booms, Nederland started absorbing the surrounding school districts. For years, Eldora preferred to send its children to Nederland and pay their way rather than join the Nederland district. Finally, in 1939, Eldora became part of the consolidated district No. 18. (Eldora Community/Bolton Collection.)

In 1919, Frenchie's store was on Eldorado Avenue between Sixth and Seventh Streets. It was owned and operated by H. M. "Frenchie" Durand and his wife, who, in spite of what it looks like in this photograph, was described as a tiny woman who used nails to pin up her hair since there were no hairpins available. Frenchie's store was torn down in 1934. (Eldora Community/Bolton Collection.)

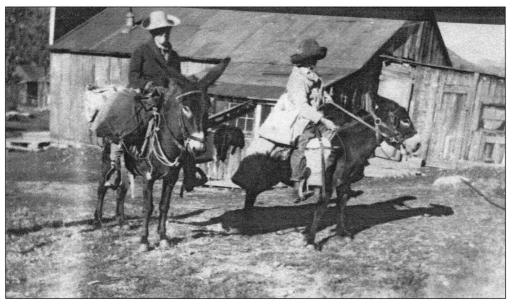

Berry picking was an important activity in the summer. Abundant huckleberries were raked from the bushes using a tool made especially for the task (below). Above, Evalyn Lilly, Eldora's town clerk, and Rebecca Wilson are returning from a successful berry-picking foray. A favorite spot for huckleberries was Chittendon Mountain. In addition to huckleberries, women and children also picked chokecherries, currants, and raspberries, all of which were used to make jams and jellies to be stored and eaten during the long winter, and pies for immediate consumption. Although they used to be so abundant that a rake could be used for picking, hardly a huckleberry bush remains in the Eldora mountain area. (Above, Eldora Community/Bolton Collection; below; Diane J. Brown.)

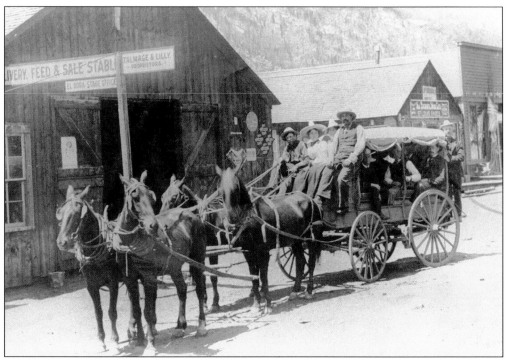

Carl Talmage and John Lilly launched a stage service between Eldora and Boulder, and two four-horse coaches brought passengers and mail to the camp daily by 1900. Driver Harry White was famous in the area for his driving skills. Sitting next to him is Mrs. Carl Talmage. The store next door is advertising St. Louis Shoes. (Eldora Community/Bolton Collection.)

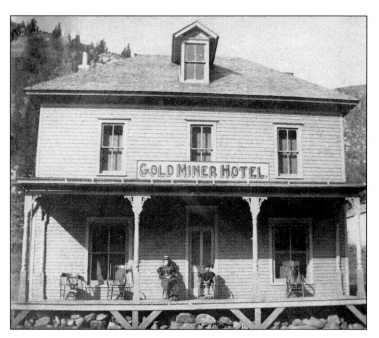

Evalyn and Harold Lilly sit on the porch of the Gold Miner Hotel. During the boom, the two-story structure was presided over by Mrs. M. Givens, who came to Eldora from Central City. When the boom had run its course in the early 1900s, Mrs. Givens sold the hotel to Mrs. Jamieson. Eldora's jail originally was at the rear of the Gold Miner before it was moved to a new location across the creek. (Eldora Community/ Bolton Collection.)

The Vendome Hotel was built during the early days of Eldorado camp on the north side of Eldorado Avenue. Mrs. L. B. DeLonde owned it. The Vendome Hotel is shown in later photographs with a false front and surrounded by other buildings. Whether that is the same building, or a new one, is not known. (George and Sandra Breymaier, Berlin Center, Ohio.)

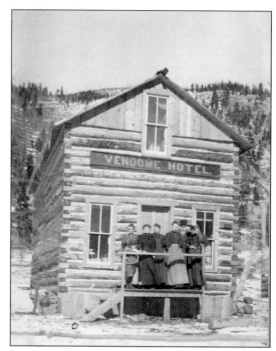

A woman and girl stop to pet burros outside the Eldora Mercantile Company store as a couple of other burros, that are already packed up for a trip back to the mine, wait patiently in front of the store. The store carried dry goods, miners' supplies, and groceries, and was the meat market. Burros that were not needed for work were often let loose to roam the town. (Eldora Community/Bolton Collection.)

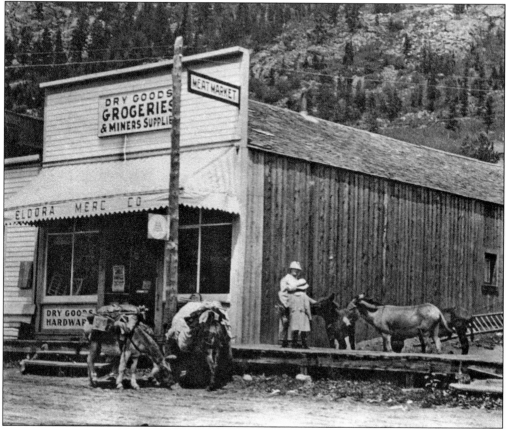

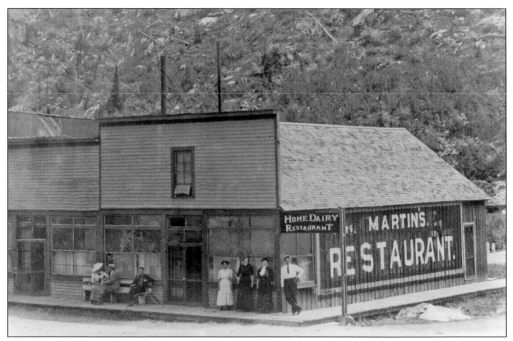

When tourists started arriving in Eldora on the mid-day and evening trains, Sarah A. Martin's restaurant was in a prime location. As the tourists arrived, John Lilly, who was at the station to load the mail sacks into his wagon for delivery to the post office, would tell them about the excellent cuisine at the Lilly restaurant and how to get to it. When the tourists walked across the bridge to enter town, they were accosted by Martin, who was standing at the open side door of her Home Dairy Restaurant, blocking their progress, and funneling them into her dining room. Those who wanted to go to Lilly's restaurant walked through the dining room and out the front door. Although her hotel was a cheerful place, Martin was known for her sharp tongue, often used to describe her distaste for tourists. (Above, Nederland Area Historical Society Collection; below, George and Sandra Breymaier, Berlin Center, Ohio.)

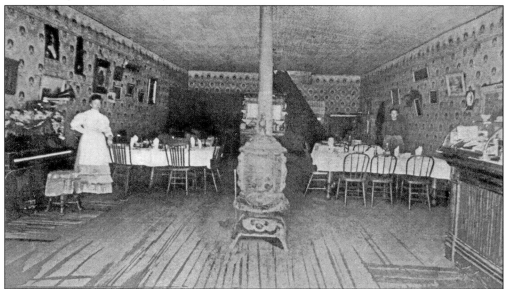

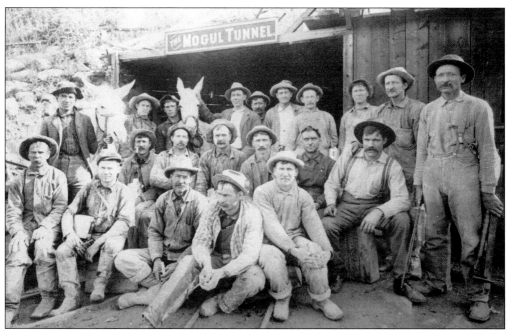

The Mogul Tunnel was financed by east coast capitalists. The tunnel was envisioned and planned by Jack Gilfillan for both transportation and drainage. The 8-foot-high and 10-foot-wide bore had a double track for moving loaded ore cars to the portal at the base of Spencer Mountain, shown here in 1900. From the bins, the ore was loaded into waiting railway cars to be taken to treatment plants in Boulder or Denver. The air compressor inside the powerhouse (below), which was located next to the creek, generated air for the machine drills and to ventilate the tunnel. Before the tunnel, ore was hoisted to the surface in buckets. Like all the other grand ventures in Eldora, the Mogul was destined to failure because the ores were low-grade, treatment costs were high, and returns from sales failed to pay production expenses. (Eldora Community/Bolton Collection.)

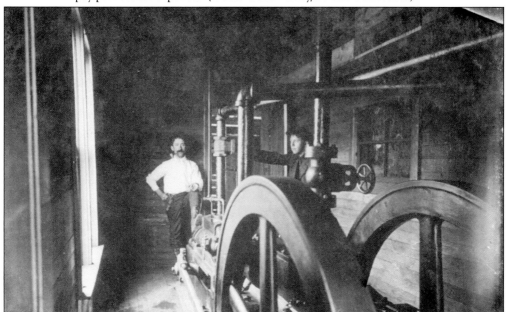

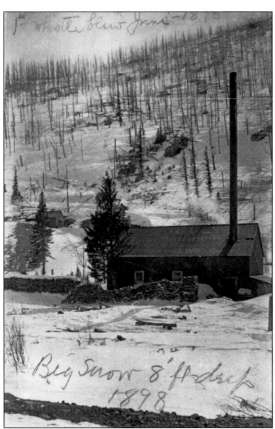

The sign on the roof of the Mogul Power House says "Drainage and Transportation / Mining and Milling Co." Spencer Mountain, rising behind the powerhouse, was burned bare in the great forest fire of 1899. Notice the huge stacks of cordwood next to the building. (Eldora Community/Bolton Collection.)

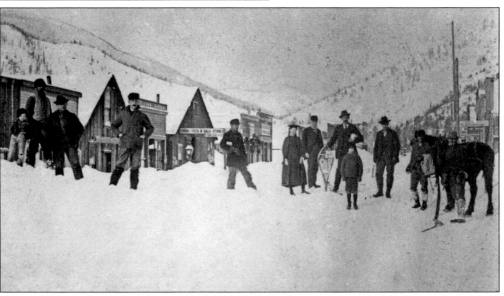

A big snowstorm in 1902 did not stop Eldora residents from getting out and about. They put on their boots, saddled their horses, and used snowshoes if they had them. The Talmage and Lilly Livery Feed and Sale Stable is on the left side of the street, and the post office is on the right. (Eldora Community/Bolton Collection.)

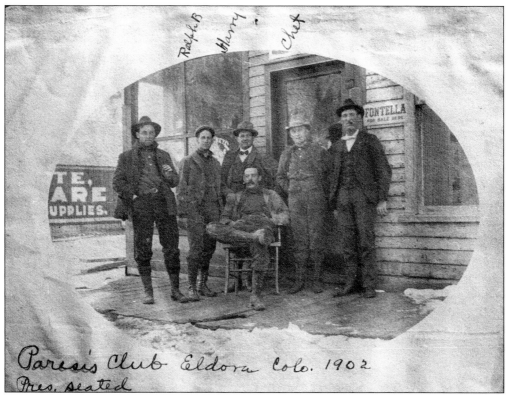

Eldora's Paresis Club had six members in 1902. Paresis clubs around the country were said to be formed to "develop the cure and seek a preventive for paresis, particularly in the theatrical profession, and not to encourage and spread the disease." In spite of that, men who joined a Paresis Club were sometimes ostracized in their communities. Paresis is a disease of the brain caused by syphilis of the central nervous system. (Eldora Community/Bolton Collection.)

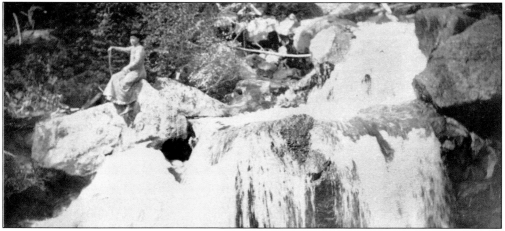

A strong and independent woman, Clara Hornback ran the grocery store that she and her husband owned in Eldora in the early 1900s, had the post office, and when she was 75 years old, worked in a defense plant during World War II. She did much of the work on the Hornback cabin in Eldora, some of it in her 80s. She is pictured here at Highland Mary Falls. (Eldora Community/Bolton Collection.)

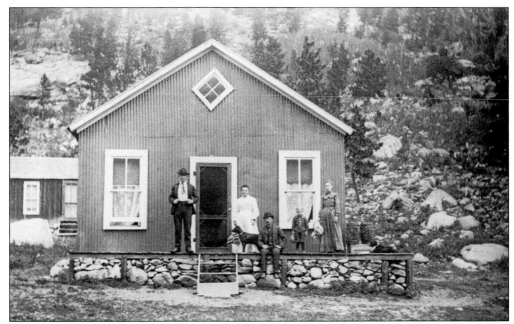

The Hornbacks moved to Eldora from Black Hawk in 1901. Charles Hornback worked in the Mogul Mine, and he and William Harpel patented two mines. He is seated in this photograph taken at Sunny Side with Mr. and Mrs. Hughs, left, and his son and wife, Verne and Clara Hornback, right. (Eldora Community/Bolton Collection.)

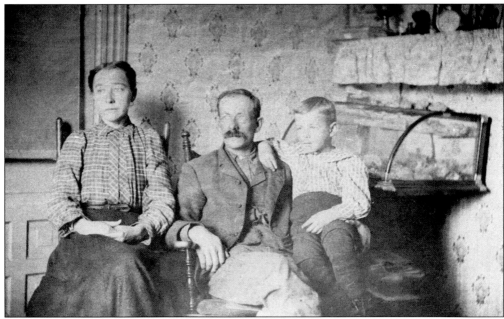

Verne Hornback was born in Black Hawk before the Hornbacks moved to Eldora. Charles and Clara opened a grocery store, and Charles worked in the mines. He died from complications from a mining accident in 1914, leaving behind his 14-year-old son Verne and a wife pregnant with twin daughters. After the twins were born, Clara moved to Denver. As an adult, Verne came back to Eldora and lived with Harpel. (Eldora Community/Bolton Collection.)

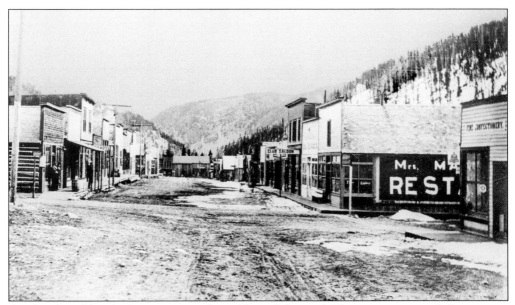

On this day, Eldorado Avenue is rutted, muddy, and deserted. The camp supported almost every kind of business, but for some reason never built a cemetery. In 1899, the town trustees appointed a Cemetery Committee, and the Boulder County Commissioners offered to sell the town a 40-acre site suitable for a cemetery for $50, but apparently the offer was declined, because to this day Eldora does not have a cemetery. (Eldora Community/Bolton Collection.)

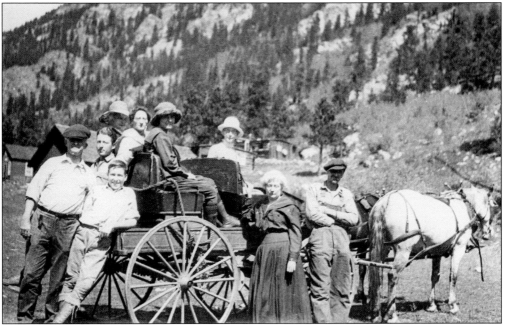

The Kopperl and O'Connor families pose with Merle Rugg, who is leaning against his rig on the right. Katie Phebus, the woman in the dark dress, worked in Fatty Mills' stores and served for a while as the town's postmaster. When Caribou miners came to town on payday, they would leave some of their earnings with Phebus so they would not drink and gamble away their whole pay. (Eldora Community/Bolton Collection.)

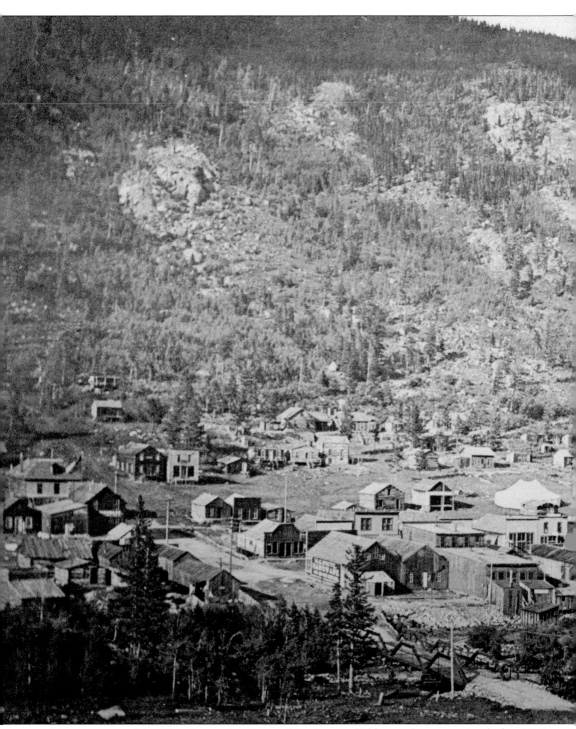

The two-story white schoolhouse dominates this picture of Eldora, taken sometime before 1913. The tall, black chimney pipe for the Mogul Powerhouse is visible in the right front corner. In the center front is the Sixth Street bridge, and above it is the M. C. White Hardware store, which later became Mrs. Martin's Restaurant. Early newspaper accounts described Eldora as "one of the more

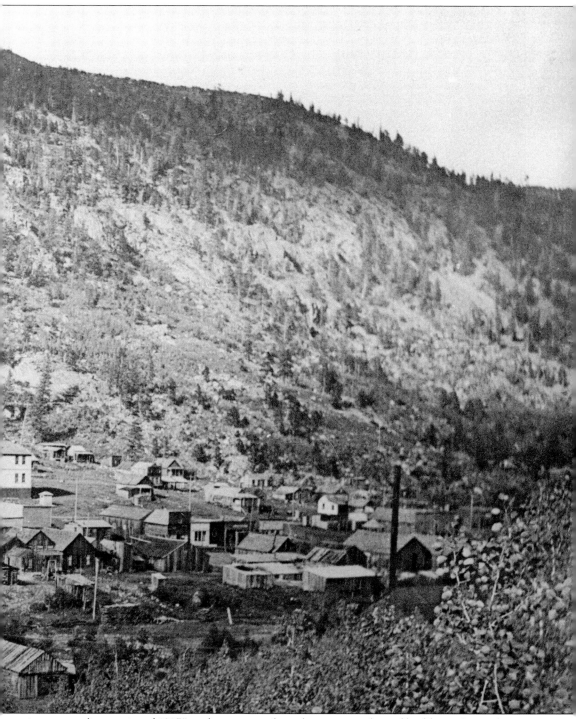

important discoveries of 1897" and commented on the superior class of buildings, "many being plastered inside and neatly painted. Corrugated iron siding and roofing is also in evidence." The *Mining Investor* of Denver said that Eldora "promises to be the leading camp of the County and will add much to the gold production of the state." (Eldora Community/Bolton Collection.)

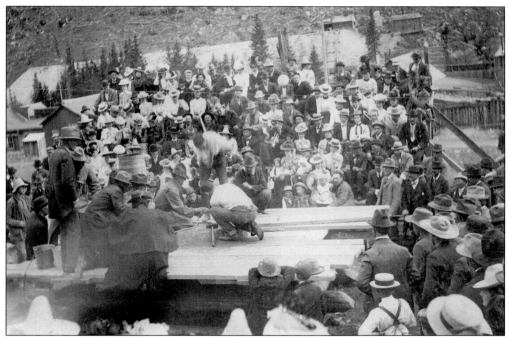

Eldora's Labor Day celebration in 1899 lasted three days and featured foot races and mining contests, where contestants from Eldora and other camps drilled into a block of granite that was quarried from the mountainside and hauled into town on a sledge. The contest platform was built around the rock. Eldora's own Fred Yockey established a world record when he sank a 23.5-inch hole in 15 minutes. (Eldora Community/Bolton Collection.)

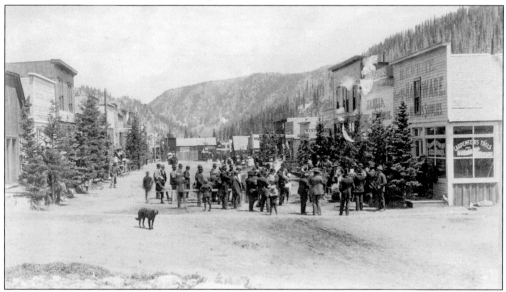

A crowd gathers during Labor Day festivities in 1899. Trees were cut and hauled into town to line the streets for the celebration, which included mining contests and lots of foot races of all kinds for men, women, and children. The festivities ended with a grand ball where, to the accompaniment of a piano, fiddle, and possibly a cornet or guitar, the crowd danced through the night, breaking only at midnight for supper. (Eldora Community/Bolton Collection.)

Rubin Rugg returns from a hunting trip with his quarry hanging from his belt. Hunting was an important way of supplementing groceries during the hard times in Eldora, and fortunately game was plentiful in the mountain area. Especially during the Depression, families in need often found meat left on their doorsteps. (Eldora Community/Bolton Collection.)

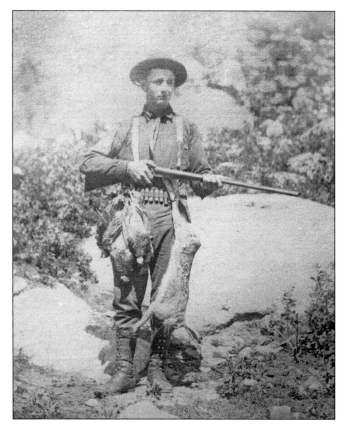

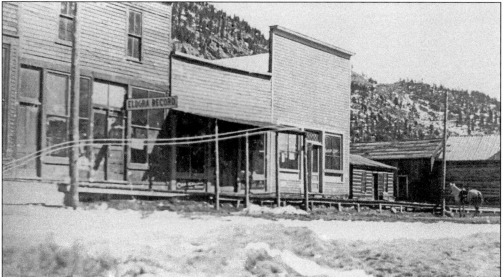

For a few years, Eldora was blessed with two newspapers. The *Miner* appeared in August 1897. A four-page Saturday paper, its subscriptions cost $2 a year. The *Record* operated from 1901 to 1909, and it absorbed the *Miner* at the end of the boom. Marvin B. Tomblin, who had succeeded Henry H. Warner as editor of the *Record*, moved the paper to Boulder, where it continued publication as the *Boulder County Miner*. (Eldora Community/Bolton Collection.)

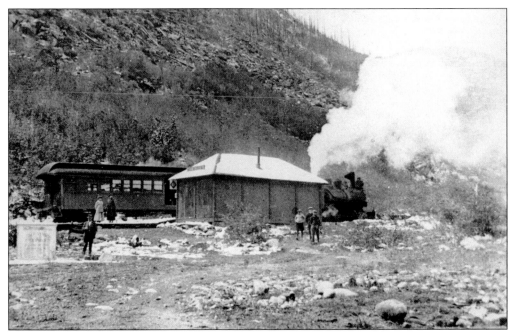

The Switzerland Trail of America advertised its "Trip to Cloudland" on "solid through trains" from Denver to Eldora and Ward. A round-trip ticket cost $2. Passengers arriving at the Eldora station are probably waiting for a wagon or stage to take them to their hotel. The gentleman at left is William T. Harpel, the mayor of Eldora. He was elected mayor in 1909 and remained in office until his death 30 years later. (Eldora Community/Bolton Collection.)

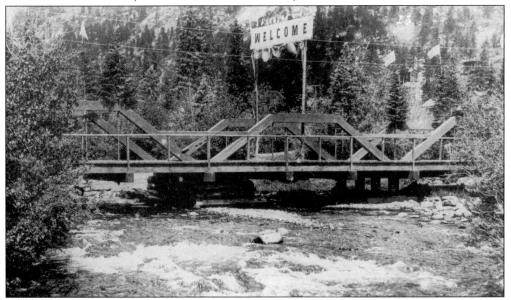

The southern branch of the Colorado and Northwestern Railroad, also known as the Switzerland Trail, was extended to Eldora in early 1905 to help transport production from the gold mines. Later the train became famous for its tourist and wildflower runs until it ceased operation in July 1919. As the train crossed the bridge and entered Eldora, passengers were welcomed with this sign over Middle Boulder Creek. (Eldora Community/Bolton Collection.)

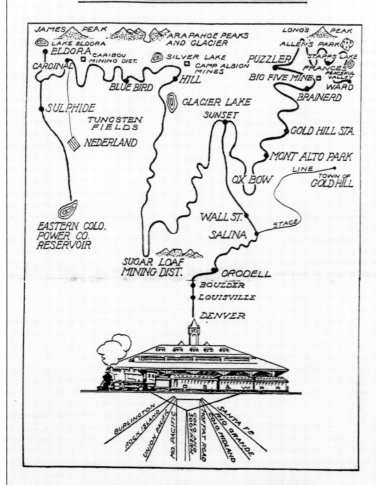

Map of

The Denver Boulder & Western Railroad

"The Switzerland Trail of America"

SOLID THROUGH TRAINS
FROM DENVER UNION DEPOT

THE ROUTE TO NEDERLAND

The Famous Tungsten Mining District, in the center of which
is Nederland, is cut in twain by The Denver Boulder &
Western Railroad. ::: Passengers for Nederland
should ask for tickets to Cardinal.

Two trains came to Eldora every day during the summer. The morning train included one or more canopy-top observation cars with wooden seats. The trip from Boulder took three hours, arriving at 12:30 p.m. and leaving at 2:00 p.m. An afternoon train carried mostly freight, and it spent the night in Eldora. The train usually turned around at a wye junction before town and backed to the Eldora station, because there was nowhere to turn around in town. (Author's collection.)

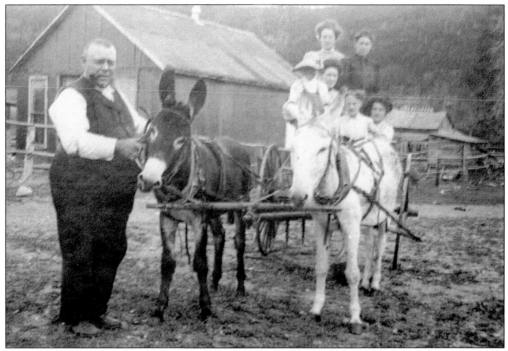

Newton "Fatty" Mills ran a general store in Eldora with partner Charles LaPoint. The store offered a huge array of merchandise including clothing, butter, beef, dynamite, prunes, and rubber boots. Mills was a favorite with the town's kids, a "jovial, gruff, and lovable" man who always carried peanuts and candy. Mills later operated one of the two theaters in Nederland from 1914 to 1921. Kathryn Phebus, Eldora's postmaster, is in the dark dress. (Eldora Community/Bolton Collection.)

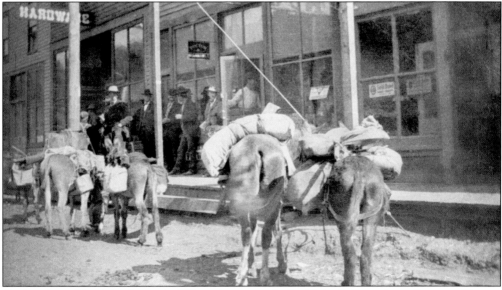

During the gold-mining boom in Eldora, burros packed with bedrolls and supplies swat flies on Eldorado Avenue. Men stand on the wooden boardwalk and lean against the buildings to chat and smoke in the shade near the hardware store, the drugstore, and a doctor's office. (Eldora Community/Bolton Collection.)

In September 1901, a forest fire spread across Woodland Flats, Woodland Mountain, and a section of Guinn Mountain. It consumed the Felch and Jones sawmill and spread up Chittendon Mountain and the west sides of Klondike and Mineral Mountains. The southern flank of Arapaho Peak, above timberline, and the denuded Caribou Flats saved the communities of Hessie and Grand Island. The two-week-long fire consumed 70,000 acres of timber and decimated Eldora's lumber industry. (Eldora Community/Bolton Collection.)

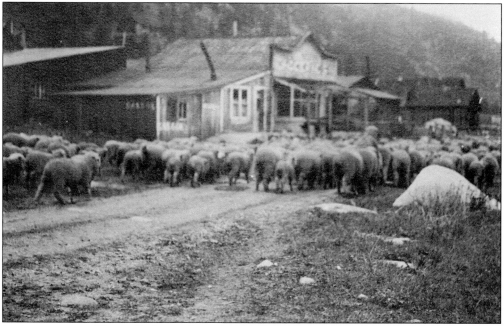

In the summer, a Platteville farmer brought his sheep up to the mountains to graze. The sheep would stay in the hills above Eldora, some wandering as far as the Continental Divide, until fall. Here, a flock wanders down Eldorado Avenue. Frenchie's general store is on the left. (Eldora Community/Bolton Collection.)

The Ponds operated a grocery store at 588 Eldorado Avenue from 1921 to 1935. The store, which also had a soda fountain, was open only in the summer. It carried a full line of groceries, milk, fresh meats, and a wonderful supply of penny candies. The produce was stored in a large cooler with ice that was cut from area ponds in the winter. Mrs. Pond was the town's unofficial mushroom expert. (Eldora Community/Bolton Collection.)

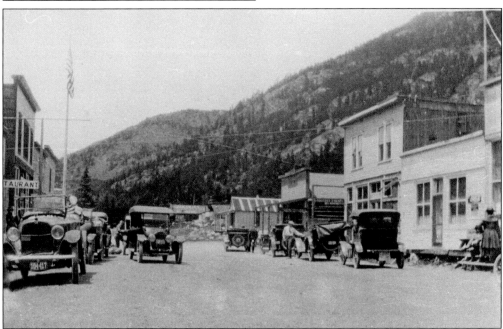

Activity was brisk on Eldorado Avenue on a summer day in 1920 when it was warm enough to travel with the top down on your automobile. The restaurant on the left became Pond's grocery. It was later sold to Oran Markem, who operated a soda fountain at the location. After that, it became a store called Mountain Shadows. (Eldora Community/Bolton Collection.)

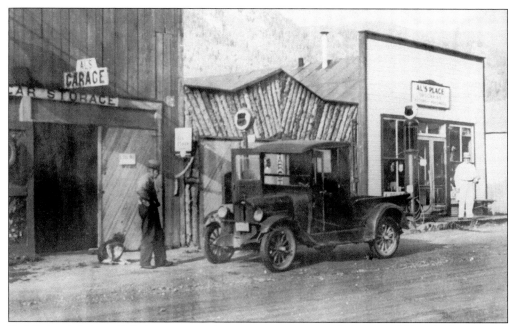

Earl Bolton's father, Al Bolton, operated a store, gas station, and garage on Eldorado Avenue just east of Pond's store in the 1930s and early 1940s. The 1929 Chevrolet belonging to John Graff, left, is stopped in front of one of the Phillips 66 pumps. Mr. Rouse stands on the porch of Al's Place near the other pump. (Eldora Community/Bolton Collection.)

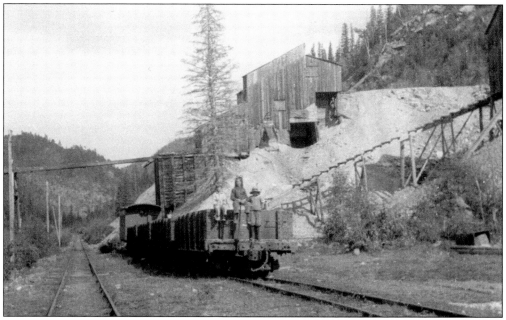

A cloudburst in July 1919 flooded the canyons west of Boulder and washed out the railroad tracks. The railroad had already been suffering loses due to the decline in mining and was in its third receivership. The flood was the last blow, and it never rebuilt. That summer, Emma Louise Fisher, Nellie Reavis, and Peggy Hurd played on one of the railroad cars near the Golden Fleece shaft house. (Eldora Community/Bolton Collection.)

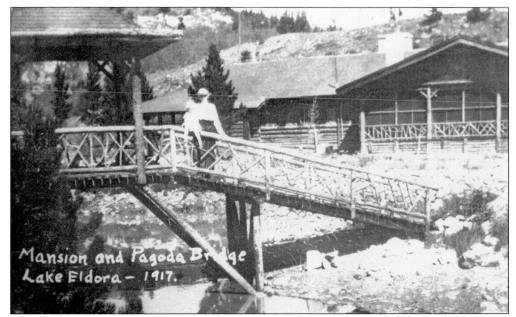

The Dixie Lodge was built by Denver socialite Annie Brown Morris in 1910 on Lake Eldora and Beaver Lake for family getaways. In 1915, Morris leased the lodge to two young entrepreneurs, Charlotte Perry and Portia Mansfield, who used it to try their idea of a dance camp that also taught outdoorsmanship. After that trial, they moved to Steamboat Springs and established the famous Perry Mansfield dance camp. (Eldora Community/Bolton Collection.)

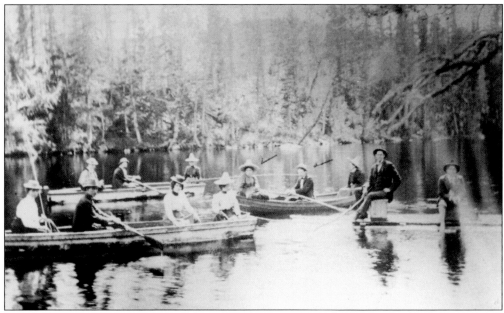

Dixie Lodge visitors could use the lodge's boats to fish on one of the lakes. Three arched bridges, with pagoda-like structures at their peaks, connected the islands and lakes to the boathouse, the lodge, and the other buildings. The roofs of the boathouse and the gazebo were painted red to enhance the Oriental look of the log buildings. The lodge burned to the ground in 1969. (Eldora Community/Bolton Collection.)

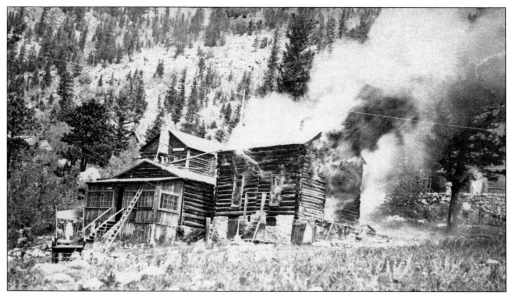

On November 28, 1902, a defective flue in the second-story stove at the Miller residence started a fire that spread through town. A harsh wind fanned the flames from structure to structure. Losses were estimated to be $15,000 and a slightly scorched school building. Twenty years later, the Rugg house caught fire, and this time the conflagration was caught on film. (Eldora Community/ Bolton Collection.)

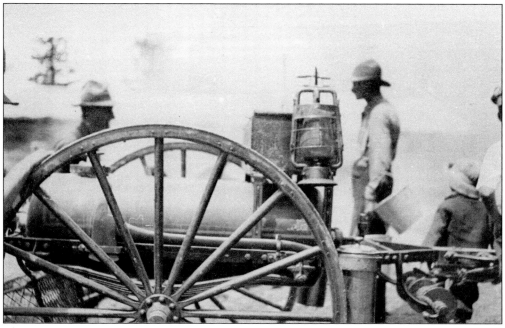

The Nederland fire department sent its old pumper and firefighters to help beat back the flames at the Rugg house in Eldora in 1922. The pumper carried water in a cistern, but by the time it arrived, smoke was already billowing out the roof, and the back of the house was totally engulfed. (Eldora Community/Bolton Collection.)

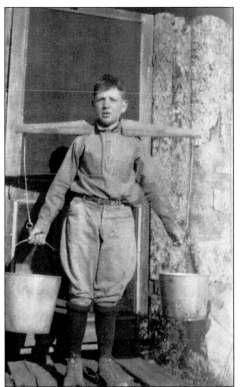

Russel Rouse carried two buckets of water at a time with the help of a yoke over his shoulders. Carrying water from the creek was a paying job for Eldora youngsters. Earl Bolton, who did not use a yoke, remembers that bringing two buckets of water to a cabin twice a day paid 50¢ a week, and sometimes the tips were good too. (Eldora Community/Bolton Collection.)

Mrs. Frazier, her daughter Margaret, and a couple of friends, including Isabella Kopperl O'Connor, stop to talk to someone by the creek on the Marysville bridge in 1919. The iron bridge railing had a distinctive X pattern and is now used for a gate. Marysville is a small community just east of Eldora. (Eldora Community/Bolton Collection.)

R. Sizer and his wife posed for this photograph at his birthday party in 1925 at their Bide-a-Wee cabin, just west of the Goldminer. The cabins in Eldora traditionally were given names like Laf-A-Lot, Rock Side, El Poco Rancho, Kill-Kare Inn, Rustic Rest, Fox Den, SummerInn-SummerNot, Here's Howe, Smile Awhile, Inn-Dianola, and Et Al. The Bide-a-Wee no longer exists. (Eldora Community/Bolton Collection.)

On hot summer days, Eldora residents always looked forward to the arrival of the "vegetable man." Joe Cohen and his son Abie brought produce to Eldora in the back of their Model T truck. They kept the vegetables cool during the trip up Boulder Canyon by covering them with a large piece of wet canvas. On the back floor of the truck, a "wash boiler" pan was filled with icy water that held delicious watermelons, and around them were piles of vegetables of all kinds. Watermelons were a treat because, like many other fruits and vegetables, they could not be grown at Eldora's high altitude of 8,641 feet. (Eldora Community/Bolton Collection.)

John H. Kemp was a mine operator in Central City, and on a hunting trip recognized the gold placer potential of the upper Middle Boulder Creek valley. He located the Happy Valley Placer, which later became the site of Eldora, in 1891. He served as the second mayor of Eldora. John H. Kemp died in 1922, and his wife died in 1931. (Eldora Community/Bolton Collection.)

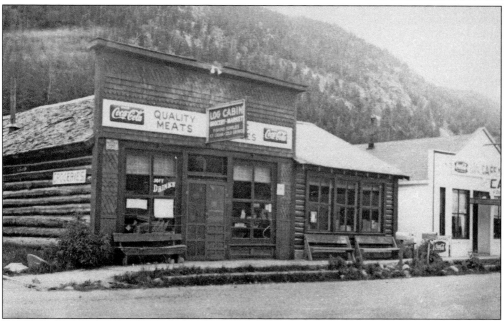

Log Cabin Corner is depicted here in 1949 at the corner of Eldorado Avenue and Sixth Street. (Eldora Community/Bolton Collection.)

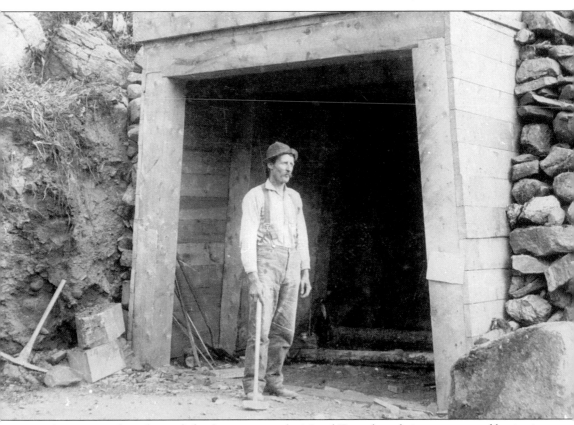

A miner sets down his tools for the camera as the Mogul Tunnel was being constructed beginning in 1897. Eventually the tunnel comprised over 6,000 feet of bore, including the main tunnel and the related crosscuts. The main tunnel intersected 30 or more veins. Unfortunately, none of the veins were rich enough to make the tunnel into a prosperous venture. (Eldora Community/ Bolton Collection.)

Four

TUNGSTEN

Stevens Camp, named for early resident Eugene Stevens, popped up just east of Nederland during the silver and gold boom, but no big discoveries of either gold or silver were ever found nearby, and the camp floundered. Meanwhile, construction on Barker Dam, just west of the slumping town, began in 1907. Finished in 1910, the dam acts as a barrier to wind and weather, and temperatures are generally 10 to 12 degrees warmer below the dam than they are in Nederland. Despite its fairer weather, population in the camp continued to decline until it was discovered how effectively tungsten hardened steel. World War I provided a tremendous demand for tungsten, and discoveries of the rare metal in and near the old mining camp brought a new boom.

Stevens Camp became the town of Tungsten. The Boulder Tungsten Production Company invested $30,000 in opening up the old town and installing milling facilities. Their investment paid for itself in just 30 days. Soon there were 17 mills running in town, many operating around the clock. Fleets of Stanley Steamers brought people looking for work up from Boulder. During the peak of the war years, estimates range from 1,000 to 5,000 people living in Tungsten and thousands more coming to town every day for work. In 1917, Tungsten boasted a post office, drugstore, billiard parlor, general store, grocery, and meat business, the Vasco Hotel, Boulder Tungsten Production Company (Clark Mill), and the Vasco Mining Company, among others.

After the war, Tungsten again slumped. By 1925, the school had closed, and the remaining children traveled to Nederland for school. In the 1920s, three buildings in Tungsten had indoor water: Ted Green's store, a company house, and the boardinghouse. The other residents used water from the water tank that sat up above the road. The tank was filled by pumping water up from the creek.

When the road between Boulder and Nederland was rebuilt in the 1940s, it was rerouted through Tungsten and took out many of the old houses. Work crews for the road lived in trailers in the old town site. Today hardly anything remains of Tungsten, but if you look closely at the hill north of the road, you can see remnants of old town streets winding upwards.

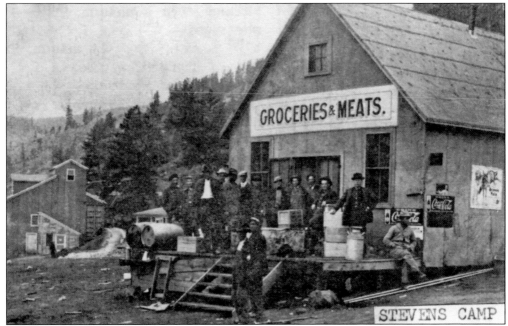

Miners crowd the porch of the Groceries and Meats store in Stevens Camp. Ads on the side of the building include the distinctive Coca-Cola logo. Many men commuted from Nederland and the surrounding area to work in Stevens Camp when it became the boom town of Tungsten. (Nederland Area Historical Society Collection.)

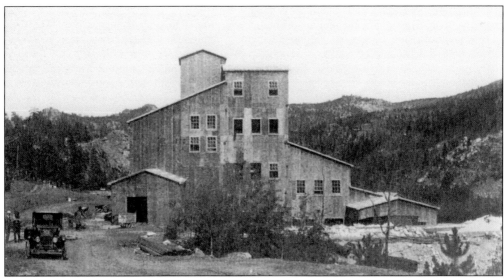

One of many mills in Tungsten, the McKenna Mill was in full operation in 1916. Between 1913 and 1916, approximately $15 million worth of tungsten was mined in the Tungsten area annually. Other mills operating in town included the Colorado Tungsten Corporation, the Tungsten Mining and Milling Company, the Primos Company, and the Boulder County Mining Company. (Nederland Area Historical Society Collection.)

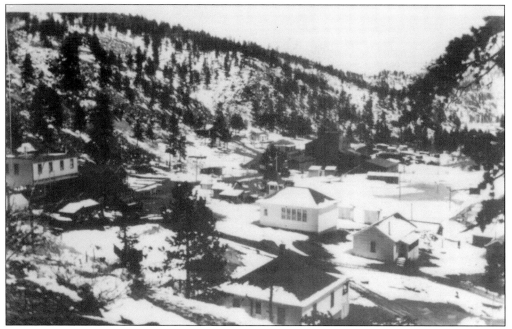

The Tungsten school, in the center with the row of windows, was filled with students throughout the town's second boom during World War I. When they were not in class, Ruby Jackson remembered carrying peanut butter buckets and picking gooseberries that their mothers used to make pies and jelly. On summer evenings, the town children played kick the can or hide and seek out back of Ted Green's store. (Author's collection.)

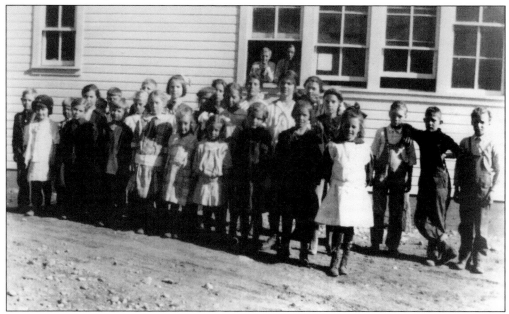

Schoolchildren pose outside the school in Tungsten about 1916. During the tungsten boom, "parents and anyone, kids even, would go around with ten-pound pails and pick up tungsten. They could make a hundred dollars in no time flat. Then all of a sudden, it went Boom! Like all things do," recalled Juanita Clark, who was born in Nederland. (Author's collection.)

Other than spooning, young people in Tungsten spent their free time climbing mountains, going on picnics, sledding, ice-skating on the millpond, and sleigh riding. Annie Bailey remembered, "In the winter, the colder the weather the better it was . . . We would live out-of-doors all winter, we just loved it . . . we were never bored." (Lana Waldron.)

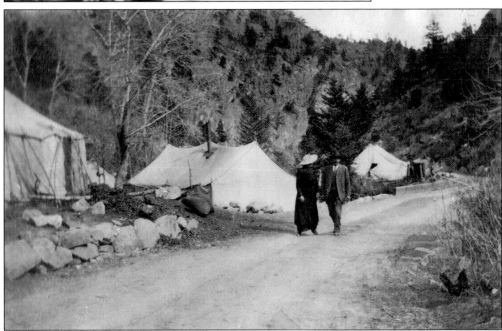

When the mining booms hit the Nederland area, tents were often the quickest and easiest way for miners to erect a home and get to work. These tents next to a bridge over Middle Boulder Creek had pipes to vent the smoke from cooking and heating stoves. Outhouses were erected nearby. These tent houses are in Boulder Canyon near the site of the mining camp of Tungsten. (Nederland Area Historical Society Collection.)

Five

AROUND NEDERLAND

Wherever miners located ore, communities formed. Some of them were just a few cabins around a mine or a mill, others were thriving communities that have long since disappeared.

Mines dotted Boulder Canyon, and camps like Wheelman were home to the miners who worked them. Sulphide, located on the flats between Eldora and Nederland, was promoted heavily as a wonderful place to live, but it never took off in spite of a fancy hotel and a lake full of trout waiting to be caught.

Some camps were company towns. The Colorado and Northwestern Railway built a stationhouse on its Switzerland Trail line in the company town of Camp Frances just south of Ward. In winter, the train crews shoveled out the snow-filled cuts so the train could make it to Ward. On April 24, 1901, an avalanche carried two locomotives down the gulch, killing two firemen, the brakeman, and the conductor.

Lakewood was built by the Primos Mining Company to house its miners and mill workers. The town had all the amenities of towns that grew on their own, but when the mines and mills closed, the Primos Company sold Lakewood to someone who hauled away every piece of lumber and mining equipment. Today nothing but a few foundations remain to mark the location of the once-thriving community.

The founder of Rollinsville did not believe in drinking or gambling, and he outlawed the vices in his new town. But one did not have to travel far to find a community that welcomed business to its saloons, including Tolland and Perigo. Today Tolland and Rollinsville remain much as they were in the past, but Perigo is just a few mine dumps and piles of lumber.

Hikers and skiers pass by some old mining camps on their treks, including Hessie and Blue Bird, which started as a mining town and became an attraction on the Switzerland Trail rail line.

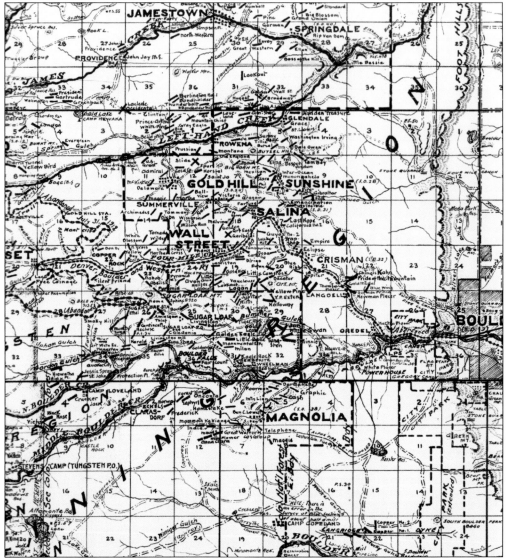

This section of Henry A. Drumm's Pocket Map of Boulder County, Colorado, shows the locations of Camp Wheelman, Ferberite, the Mojave Mill, and Stevens Camp/Tungsten. It also shows the route of the Switzerland Trail of America railroad as it snaked its way up Four Mile Canyon. (Author's collection.)

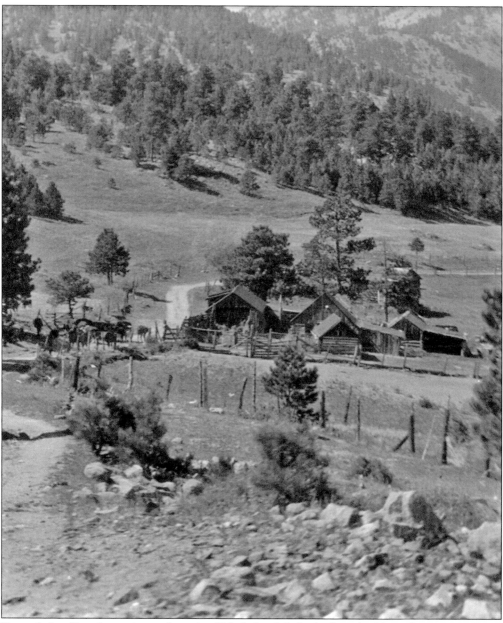

Forest Lakes Ranch was located north of Nederland. It had a long building that was used as a bunkhouse and dining room, a barn, and a fourplex for the ranchers, in addition to a number of other buildings. The old cattle ranch is now part of Caribou Ranch. (Nederland Area Historical Society Collection.)

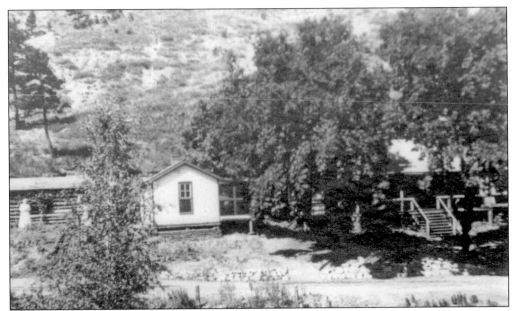

The Alps Resort in Boulder Canyon was a restaurant and accommodations for travelers on the Switzerland Trail Railroad. Guests would arrive and depart from the railway station just north of the resort at the confluence of Boulder and Four Mile Creeks. The Alps property had one of the first trout farms in Colorado, operated by the Boulder Fish and Game Club. (Nederland Area Historical Society Collection.)

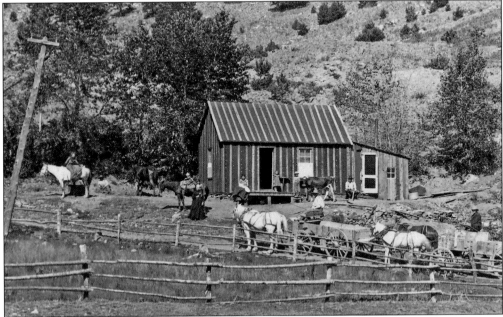

The Nederland area was home to a number of farms and ranches, including this unidentified, but obviously prosperous one. Some of the earlier ranchers were William Hannah, Henry Commeaw, Newton Hockaday, a Mr. Sexton, S. M. Breathe, and Able Goss. Later came Alfred Tucker, Frank Fisher, Tom Hill, and Frank DeLong, who was rumored to have been killed by his brothers. (Jimmy Griffith Collection.)

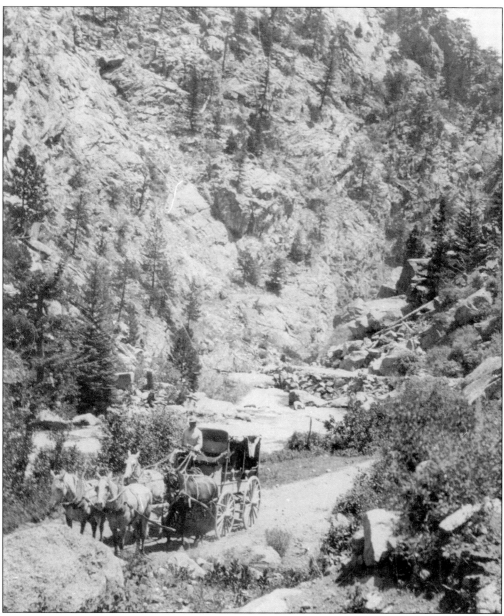

The Lilly stage makes its way up Boulder Canyon. Carl Talmage and John Lilly began operating a stage line based in Eldora in 1895. The line maintained a stable and corral in Boulder at the corner of Spruce and Fifteenth Streets. One four-horse coach left Boulder after loading mail sacks and passengers who had arrived from Denver on the 9:30 a.m. train. At the same time, another coach left Eldora after making the rounds of the hotels and houses to pick up passengers. The coaches stopped at the Half-Way House for lunch and to switch teams. The toll for the Boulder Canyon road was $1.50. Many miners and prospectors arrived in Eldora via one of the stagecoach lines that were operating during the mining boom, including Jay M. Church, Hull and Fitting, and P. Frank Little, who eventually began operating a light two-seat buggy drawn by a fast team, which he called "Little's Flyer." The new rig cut the running time between Boulder and Eldora by 30 minutes. (Eldora Community/Bolton Collection.)

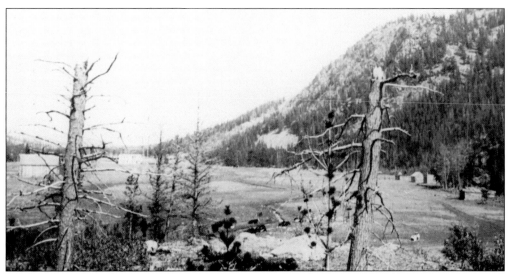

The town of Sulphide was named after the prevailing ores in the vicinity. Although an elaborate town site was planned, the town itself lasted only a few years. At its peak, Sulphide consisted of two false-fronted commercial buildings, a few small cabins, and a two-story frame hotel, the St. Julien, the large building in the center left that overlooked a small lake. The town was located on the flats between Eldora and Nederland. (Eldora Community/Bolton Collection.)

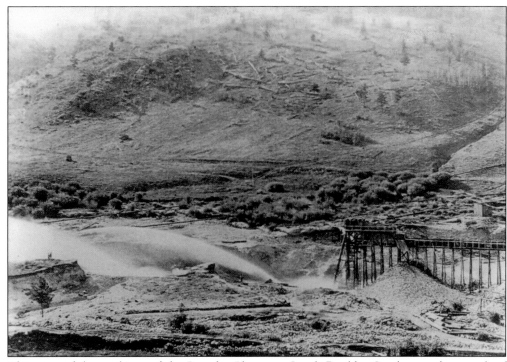

This view of the workings of the Pactolus Placer on South Boulder Creek near the mouth of Winiger Creek shows the elevated pipe system, tailings piles, and ponds. Both placer mining and hard rock mining techniques were employed in the Nederland area by gold miners. (Nederland Area Historical Society Collection.)

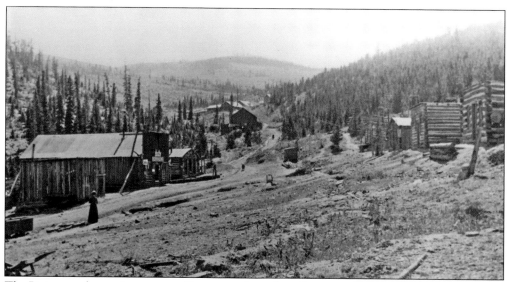

The Perigo amalgamation stamp mill processed ores from Perigo and Gold Dirt, two lodes located on opposite sides of Gamble Gulch by John M. Dumont and his partner Hiram Perigo in 1859. Depending on which source is believed, the Perigo mine produced between $30,000 and $2 million. At first, the town that grew up around the mines was called Gold Dirt, but it was later renamed Perigo. One and two-room log houses were built, and saloons and stores popped up along the business street, including the grocery store pictured here. Perigo was a sociable camp—the Perigo Social Club was very exclusive, and community dances were held frequently. The town also made efforts to attract road shows from Denver and attempted serious theater. (Above, Eldora Community/Bolton Collection; below, Nederland Area Historical Society Collection.)

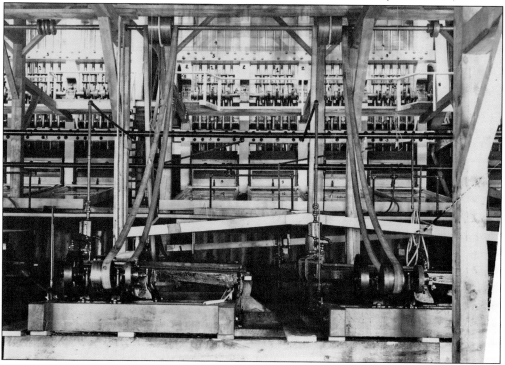

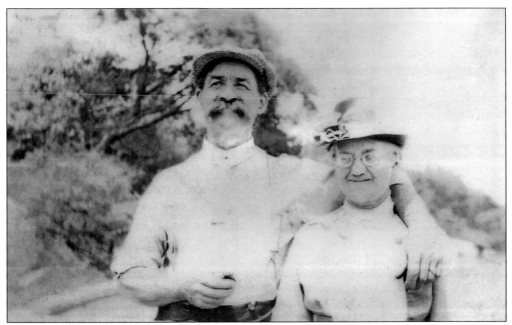

Jack Iverson and his wife owned the Jumbo mine near Tolland in 1916. Jack Iverson's family came to the United States from Copenhagen, Denmark, in 1889 on a ship called the *King Valla*. He came to Tolland hoping, as all miners do, to make his fortune. (Nederland Area Historical Society Collection.)

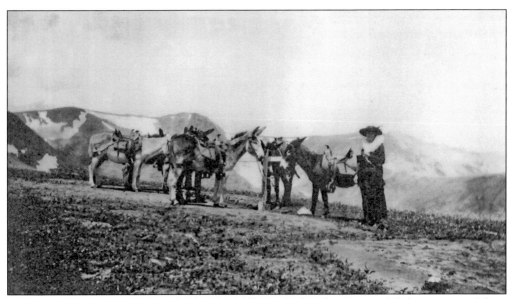

When Hermina Iverson and her husband, Halfden, who lived in Detroit, Michigan, visited their uncle, Jack Iverson, and his wife in Tolland in 1916, they took a sightseeing trip to Corona at the top of Rollins Pass on the Moffat Road. There they threw snowballs and took pictures. Hermina dressed up for the burro ride to 11,660 feet. (Nederland Area Historical Society Collection.)

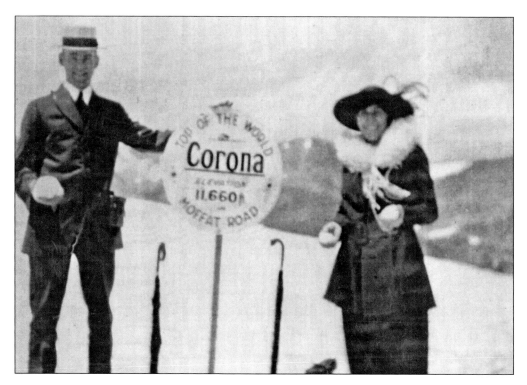

People who traveled to the top of Rollins Pass were often amazed that snow remained at the high altitude in the summer months. Many of them had photographs similar to these taken. Hermina and Halfden Iverson are holding snowballs, and Mrs. Jack Iverson posed with her nephew Halfden at the rock pile at the top of Rollins Pass. Photographs like these were treasured mementos of a trip to the Rocky Mountains. Half and Minna, as their family called them, eventually moved from Detroit, Michigan, to Portland, New York, keeping these photographs of their trip to Tolland in 1916 to hand down to future generations. (Nederland Area Historical Society Collection.)

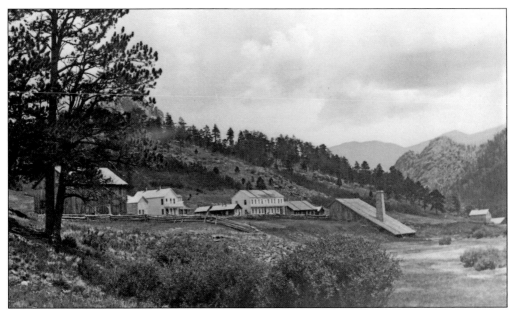

Rollinsville was founded by John Q. Rollins shortly after the Colorado gold rush began in 1859. Rollins decreed that there would be no saloons, gambling houses, or dance halls in the town. He also laid out and constructed the first wagon road over the Continental Divide, and it was mostly over his grade that the Moffat railroad was built. (Nederland Area Historical Society Collection.)

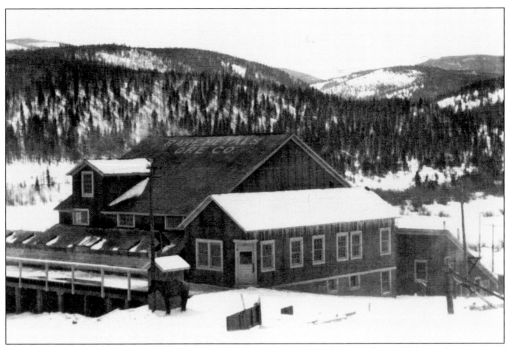

John Q. Rollins built a six-stamp quartz mill in his new town to handle the gold from the mines of Perigo and Gold Dirt. The Rollins Steam Quartz Mill was enlarged to 12 stamps and later 16. It was torn down to make way for the railroad. A later mill, the Rare Metal Ores Company, is pictured from the northeast in 1917. (Courtesy U.S. Geological Survey/photograph by F. L. Hess.)

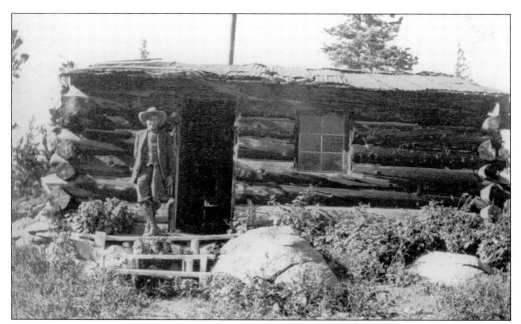

Jesse B. (Jay) Rowley poses in front of his cabin at the junction of the Hessie Road and the Fourth of July Road. Rowley prospected throughout Boulder County, and he located the Delaware Mine in the Grand Island District and several prospects on Spencer Mountain. In the Lost Lake area, he staked out the Shirley, X-Ray, Amy Paul, and other mines. (Eldora Community/ Bolton Collection.)

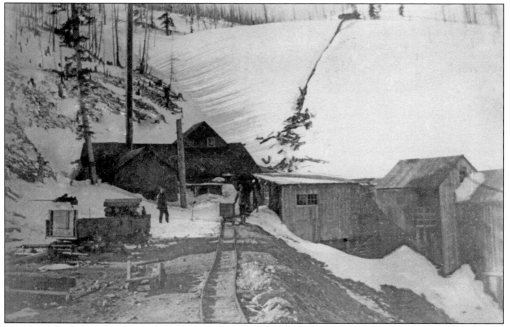

Workers skid cordwood for the mine boilers through a 30-foot snowdrift to the shaft house at the Revenge Mine at Lost Lake west of Hessie. Gold ore from the Revenge was processed at the Norway Mill, which was built beside the dump at the Revenge with track leading from the tunnel portal directly to the mill. (Eldora Community/Bolton Collection.)

F. M. Strawhun staked the Revenge Mine on August 18, 1897. The mine clings to the steep mountainside above Lost Lake, which is frozen in this wintertime photograph. About 3 miles west of Eldora, the Revenge never produced on its early promise. The access was difficult and the mine was often flooded. (Eldora Community/Bolton Collection.)

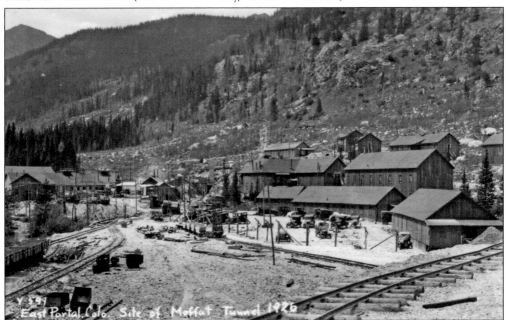

Workers lived in this camp at East Portal during the construction of Moffat Tunnel. The tunnel bored through the mountain that David Moffat's railroad had snaked up and over on Rollins Pass. Construction started in 1923, and the tunnel opened in 1927, costing $18 million and 19 lives. When it was completed, it was the longest train tunnel in North America and remains the second-longest today. (Author's collection.)

Capt. J. H. Davis laid out a small town 2 miles west of Eldora and named it Hessie in honor of his wife. The population may have reached a high of 80 in 1901 with a post office, a schoolhouse, a couple of stores, a sawmill, and a number of cabins. The town also was the site of a ranger cabin, but it never was in continuous use. (Eldora Community/Bolton Collection.)

Champ Smith, a tall, gray-haired, blue-eyed bachelor in his early 50s, lived and worked his mine near Hessie. On June 13, 1914, a neighbor discovered Smith's body. Although it looked like he was killed in an accidental dynamite explosion, the sheriff's chief investigator thought Smith, who had recently been appointed a temporary game warden, was probably murdered. Wilson Davis and the Smalley brothers were arrested but never brought to trial for the murder. (Eldora Community/Bolton Collection.)

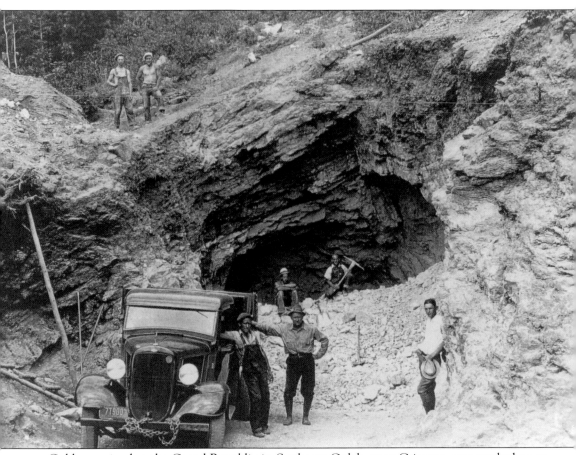

Gold ore mined at the Grand Republic in Sunbeam Gulch, near Crisman, was trucked up to Gold Hill and down Lickskillet Gulch to the Cold Spring mill. A fleet of Chevrolet trucks was kept busy transporting 100 tons a day to the rehabilitated mill in the 1930s. (Nederland Area Historical Society Collection.)

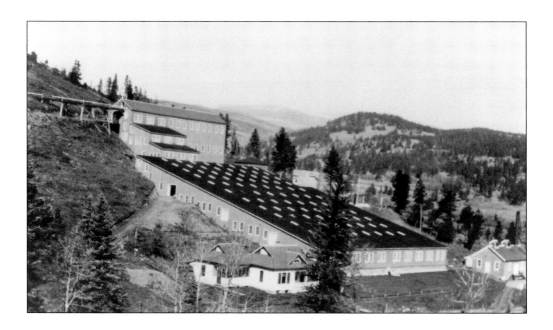

Lakewood, about 4 miles north of Nederland, was built as a company town. In the early 1900s, steel manufacturers Stein and Boericke became interested in the tungsten-producing Conger Mine. After acquiring the Primos Chemical Company, they merged with Great Western Exploration of Colorado. Three years later, they consolidated the holdings of Boulder County Ranch and acquired the Conger Mine. Chauncey F. Lake, who had managed the Conger Mine, became resident manager of the huge new company, the Primos Mining and Milling Company. The Primos Company built the largest tungsten mill in the world not far from the Conger Mine. A small company town called Lakewood grew up near the mill. Pictured above is the mill with Lake's residence on the left. Below is the view looking down on part of the town. (Nederland Area Historical Society Collection.)

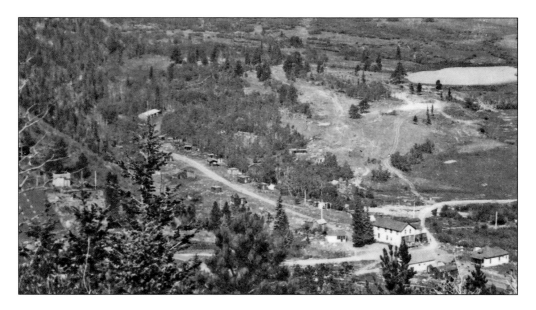

Lakewood, built on land that once was the ranch of Thomas J. Hill, was close enough to Nederland that people walked back and forth between the two towns, just to visit with friends or for parties and dances. Like all the area's mining towns, Lakewood had a theater (above), which was the scene of many area events. One machine operating in Lakewood that was "extremely interesting" to the boys of the community was the small train that carried ore from the mines to the mill. For one boy's birthday, the party guests walked to Lakewood, where they had a bonfire and hot dogs, and then walked back to Nederland. (Nederland Area Historical Society Collection.)

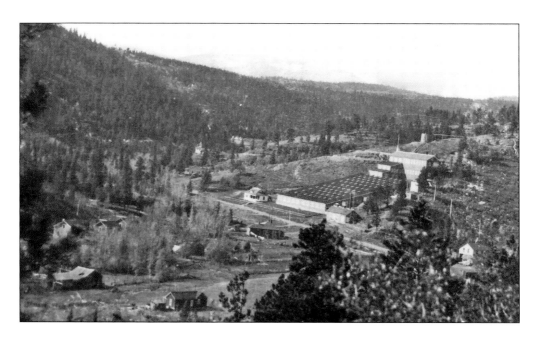

From a distance, the Primos mill dominated the town. One of the nicer houses in Lakewood that was probably built for one of the Primos Company managers stands empty after the United States started importing tungsten from China and the Primos Company disappeared. The Vanadium Corporation of America purchased the Primos properties in 1920, and immediately sold the town of Lakewood to L. W. Wells, a Boulder mine equipment dealer, who dismantled and removed 30 residences and small buildings and the mill building and its machinery. Nothing remains today of Lakewood except for a few foundations and the view. (Nederland Area Historical Society Collection.)

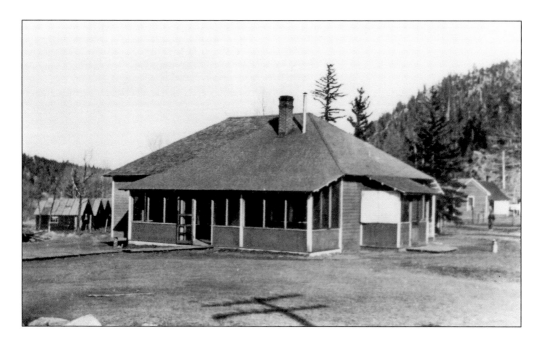

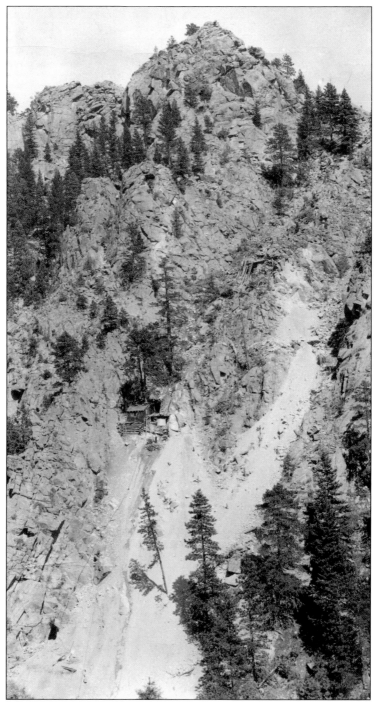

The workings of the Mojave Boulder Tungsten Mining Company on its Good Friday claim cling to the rock wall in Boulder Canyon when this photograph was taken on March 9, 1917. The mine was on the northeast side of the junction between North Boulder and Middle Boulder Creeks, just below Boulder Falls, 8 miles west of Boulder. (Courtesy U.S. Geological Survey/photograph by F. L. Hess.)

A small camp sprang up by 1887 north of Magnolia and east of Boulder Falls along Boulder Creek in Boulder Canyon. Close to the Eagle Rock Mine, it was variously called Camp Eagle Rock and Camp Wheelman. Other mines were worked between the camp and Bummer Gulch to the north. (Nederland Area Historical Society Collection.)

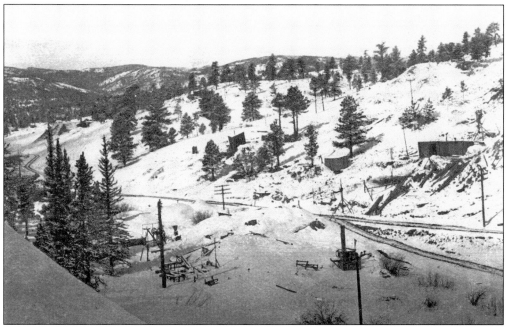

The Clyde mine, about 2.5 miles north of Nederland, was owned by the Wolf Tongue Mining Company from 1907 to 1929. It was a highly productive tungsten mine, especially when this photograph was taken in 1917. The mine reached depths of 503 feet and had over 4,725 feet of underground workings. (Courtesy U.S. Geological Survey/photograph by F. L. Hess.)

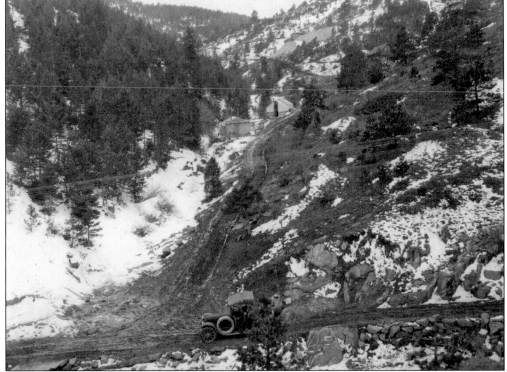

The Katie Ferberite mine is on the right in this photograph looking up Millionaire Gulch in the Sugarloaf area in 1917. The Dorothy mine of the Tungsten Metals Corporation is at the head of the gulch. Ore from the mine was processed at the nearby Ferberite Tungsten Mill. (U.S. Geological Survey/photograph by F. L. Hess.)

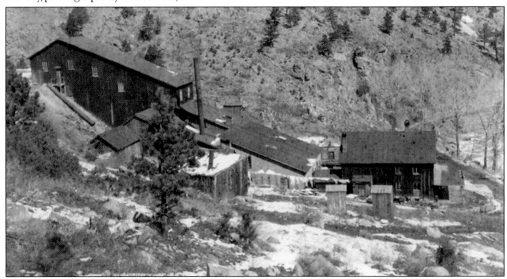

Ferberite was comprised of a small community of workers at the Ferberite mine and mill. It was just east of Boulder Falls in Boulder Canyon. The Ferberite Tungsten Mill was a half mile above the town. This photograph of the mill was taken on March 4, 1917. Ferberite is the iron-rich variety of wolframite and a source of tungsten. (U.S. Geological Survey/photograph by F. L. Hess.)

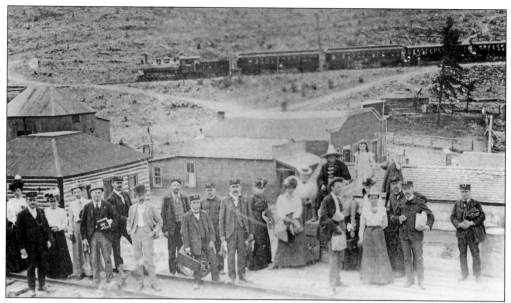

Camp Frances was a busy mining camp and important railroad link south of Ward. About 200 people lived in this town that was operated by the Big 5 Mines Company syndicate. It existed through the 1890s, when a large syndicate took over many of the mines. Typical of mining camps in the area, the surrounding hillsides have been logged bare. The Meat Market is the building with a sign in the center of this picture, which was taken in 1901. (Nederland Area Historical Society Collection.)

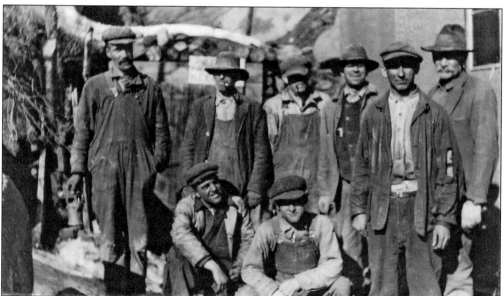

Blue azurite, often found in silver ore, gave the Blue Bird mine its name. In the 1870s, miners flocked to work at this and other mines in the area. The site included a bunkhouse, a mining company house, chicken coops, a smokehouse, and a mill. The North Boulder mill was built down the road in the town of Batesville on the bank of North Boulder Creek to process the silver ore. In 1905, Blue Bird became a tourist attraction on the newly completed Eldora Line of the Switzerland Trail of America railroad. (Jimmy Griffith Collection.)

BIBLIOGRAPHY

Becker, Isabel M. *Nederland: A Trip to Cloudland*. Denver, CO: Scott Becker Press, 1989.

Boyd, Leanne C., and Glenn H. Carson. *Atlas of Colorado Ghost Towns, Volume 1*. Deming, NM: Cache Press, 1984.

Brown, Robert L. *Ghost Towns of the Colorado Rockies*. Caldwell, ID: The Caxton Printers, Ltd., 1969.

Buchanan, John W., and Doris G. Buchanan. *The Story of Ghost Town Caribou*. Boulder, CO: Boulder Publishing, Inc., 1957.

Cobb, Harrison S. *Prospecting Our Past: Gold, Silver, and Tungsten Mills of Boulder County*. Longmont, CO: Book Lode, 1999.

Kemp, Donald C., and John R. Langley. *Happy Valley, A Promoter's Paradise*. Denver, CO: Smith Brooks Printing Company, 1945.

Kemp, Donald C. *Silver, Gold, and Black Iron: A Story of the Grand Island Mining District of Boulder County, Colorado*. Denver, CO: Sage Books, 1960.

Meyring, Geneva. *Nederland, Then and Now*. Boulder, CO: Boulder Publishing, Inc., 1941.

Pettem, Silvia. *Excursions from Peak to Peak: Then and Now*. Longmont, CO: Book Lode, 1997.

Smith, Duane A. *Silver Saga: The Story of Caribou, Colorado, Revised Edition*. Boulder, CO: University Press of Colorado, 2003.

Waldron, Lana, et al. *Boulder County Women: Some Oral Histories*. Boulder, CO: University of Colorado thesis, 1978.

INDEX

DISCOVER THOUSANDS OF LOCAL HISTORY BOOKS
FEATURING MILLIONS OF VINTAGE IMAGES

Arcadia Publishing, the leading local history publisher in the United States, is committed to making history accessible and meaningful through publishing books that celebrate and preserve the heritage of America's people and places.

Find more books like this at
www.arcadiapublishing.com

Search for your hometown history, your old stomping grounds, and even your favorite sports team.

Consistent with our mission to preserve history on a local level, this book was printed in South Carolina on American-made paper and manufactured entirely in the United States. Products carrying the accredited Forest Stewardship Council (FSC) label are printed on 100 percent FSC-certified paper.

MADE IN THE USA